HOT
Shots

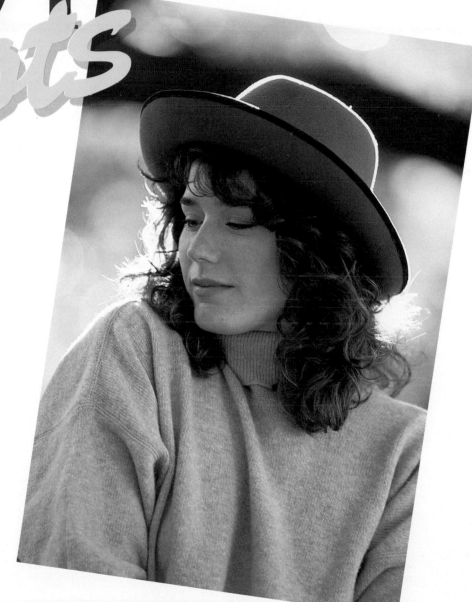

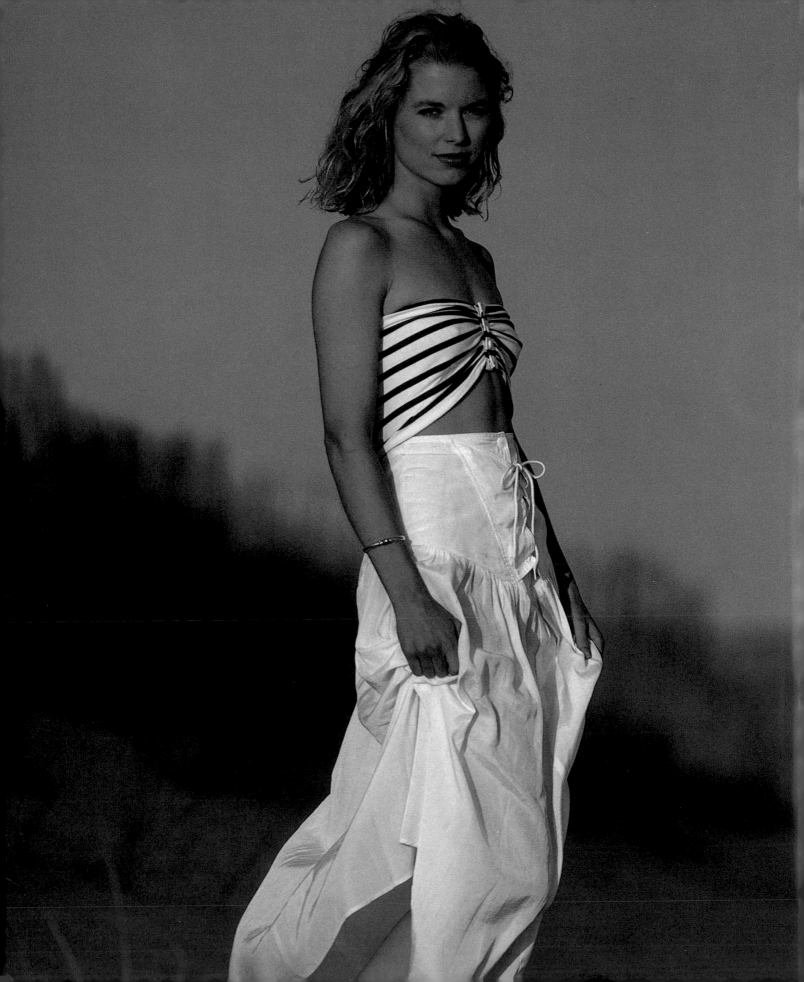

J. BARRY O'ROURKE

HOT
Shots

AMPHOTO
AN IMPRINT OF WATSON-GUPTILL PUBLICATIONS
NEW YORK

To my crew (family) who have been there through thick and thin:
my son, Randy, a successful magazine photographer; my daughters, Cindy, a food stylist and
super jock, and Shannon, a model and mother-to-be; and Carol, my wife, mother, pal,
producer, critic, and constant source of inspiration. How fortunate I am to be in a profession
that enables me to work and travel with each of them on a professional level.

Thanks to all those wonderful people who helped make this book possible: former and current assistants (a great group of "right hands") John F. Bourke, Brian Edwards, Bob London, Rosemarie Mattrey, Patrick McHugh, and Steve Tague; hair-and-makeup artists Elizabeth Fried, Elaine Good, Ken-Ichi, and Jody Pollutro; models Lisa Accomando, Chris Breed, Debbie Brett, Peggy Collins, Pam Coy, Tanya Eggers, Eleana, Tom Fitzsimmonds, Kim Forbes, Cornelia Furbert, Kelly Futerer, Ginger Garrett, Leah Gordon, Victoria Hewett, Fabiane Heymans, Sherri Holmes, Leslie Hubbard, Anthony Jones, Kathy Karges, Heidi King, Angela Lamb, Sherri Montgomery, Ingrid Pico, Sharon Proto, Pat Quinn, Hoyt Richards, Shannon, Sharka, Annita Sklar, Robert Sporre, Lisa Stimmer, Caaren Tietje, Tom Tripodi, Susan Van Horn, Kim Verbeck, and Carol Workinger; stylists Jocelyn Braxton, Debbie Donahue, Amy Sacks, and Nicole Zizelis.
Special thanks to Julie Thomas, my studio manager, fill-in assistant, and great cook!

Copyright © 1992 by J. Barry O'Rourke
First published 1992 in New York by AMPHOTO,
an imprint of Watson-Guptill Publications,
a division of BPI Communications, Inc.,
1515 Broadway, New York, NY 10036

Library of Congress Cataloging-in-Publication Data

O'Rourke, J. Barry.
 Hot shots.
 Includes index.
 1. Glamour photography. I. Title.
 TR678.076 1992 91-43403
 778.9'24—dc20
 ISBN 0-8174-3994-3
 ISBN 0-8174-3995-1 (pbk.)

Manufactured in Singapore

1 2 3 4 5 6 7 8 9 / 00 99 98 97 96 95 94 93 92

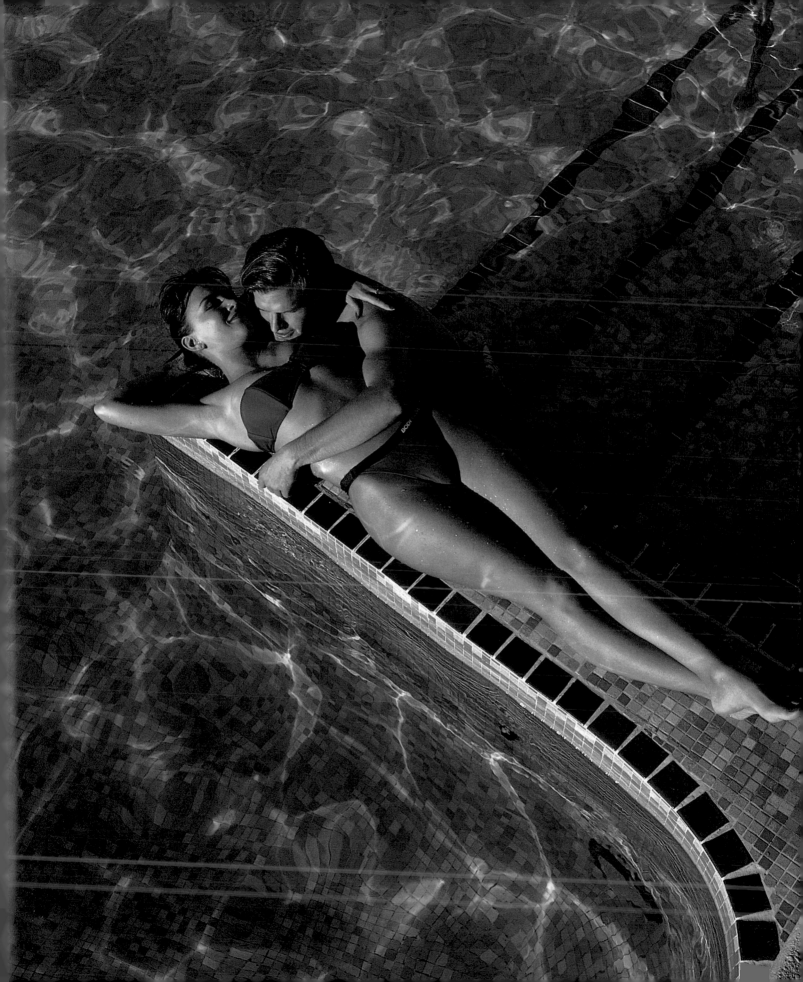

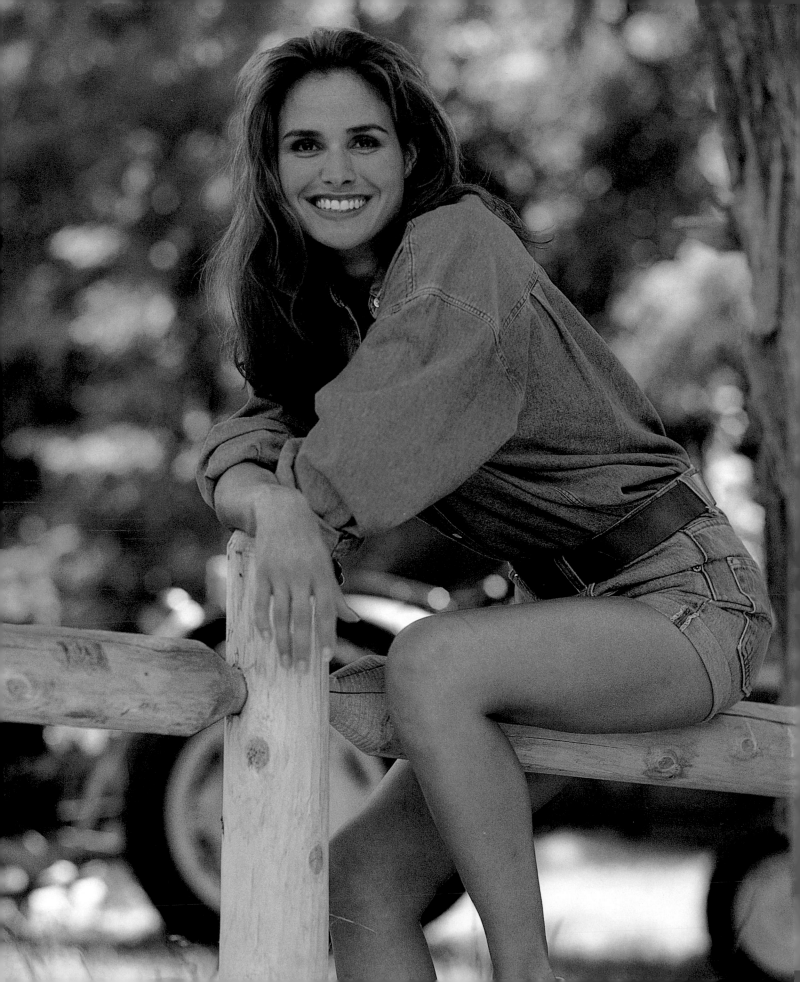

CONTENTS

INTRODUCTION

Basic beauty photography hasn't changed during the last four or five years. But there has been a mini-revolution in terms of what is good, what is merely acceptable, and what will be "in" the following year! The industry has been going through a period of desperately grasping at the latest trend in lighting or pushing film or at whatever seems to grab the highest number of art directors visually. Buyers of advertising and editorial photography have been searching frenetically, trying to "discover" someone with a different look, approach, or technique. And they have a great deal to choose from. When you flip through the various sourcebooks, you notice that they contain absolutely beautiful shots representing the work of hundreds of new photographers.

Then when you walk through drugstores to the beauty-and-health-care sections, look carefully at all of the packages for such products as shampoos, shaving supplies, skin creams, bath oils, and cosmetics. You'll find that the shots could've been made five or ten years ago. The market for well-executed beauty shots—well-lighted, fully saturated exposures—is huge. In order to sell their products, clients usually want to see photographs on the package that say "Look at me. I am beautiful because I use product X." Because of the enormity of this industry, I've devoted the first part of this book to making ordinary people look beautiful and beautiful people look fantastic!

For the most part, I haven't changed or added any new equipment in the last several years; the only exception is an entire set of new strobes. Based on recommendations from a number of photographer friends and Larry Farrell of Flash Clinic in New York City, I purchased a number of Dyna-Lite power packs and heads for location work. Their size and weight are wonderful, and they are very dependable and versatile.

The films represented in *Hot Shots* vary widely because I tried different emulsions for particular reasons. Over the past several years, this is one of the areas of photography that have seen the most change. The multitude of film choices enables you to suit any style you might want to pursue. Also, the depth and tonal range of black-and-white films have been greatly enhanced via the introduction of Kodak's T-Max films and the extended use of 35mm black-and-white Polapan by professionals for reproduction purposes. Why this sudden interest in black and white? Is it the great print quality now readily available to even darkroom novices; the trendiness of the business, which is looking for a change; or the rediscovery of a lot of the work done during the 1930s and 1940s by a handful of photographers? I think that the increased use of black-and-white film is simply an accidental combination of the three, with a boost from *Vanity Fair* magazine at the right time.

Photographers who are interested in shooting portraits should think of *Vanity Fair* as their primary reference book. Even though most of the subjects are celebrities, the photographs are usually wonderful and not always in color. Black and white has a particular elegance that at times is much more commanding than color. Images by Irving Penn and Richard Avedon, for example, are timeless photographs executed by masters of both the psychology of portraiture and black-and-white technique. The strength of some of their portraits lies in the fact that the images are black and white.

Of course, the compelling nature of the subject matter can't be overlooked. As Edward Steichen pointed out in *U. S. Camera* (October 1939), "In photographing an actor, the photographer is given exceptional material to work with. In other words, he can count on getting a great deal for nothing, but that does not go too far unless the photographer is alert, ready and able to take full advantage of such an opportunity." This observation related to a series of shots that Steichen had made of actor Paul Robeson, who was appearing in the film *Emperor Jones*. These black-and-white photographs are wonderful representations of the Hollywood lighting of the time. This type of illumination incorporated strong highlights; dark, dramatic shadows; dark backgrounds; and emphatic hand gestures, something that most photographers don't even

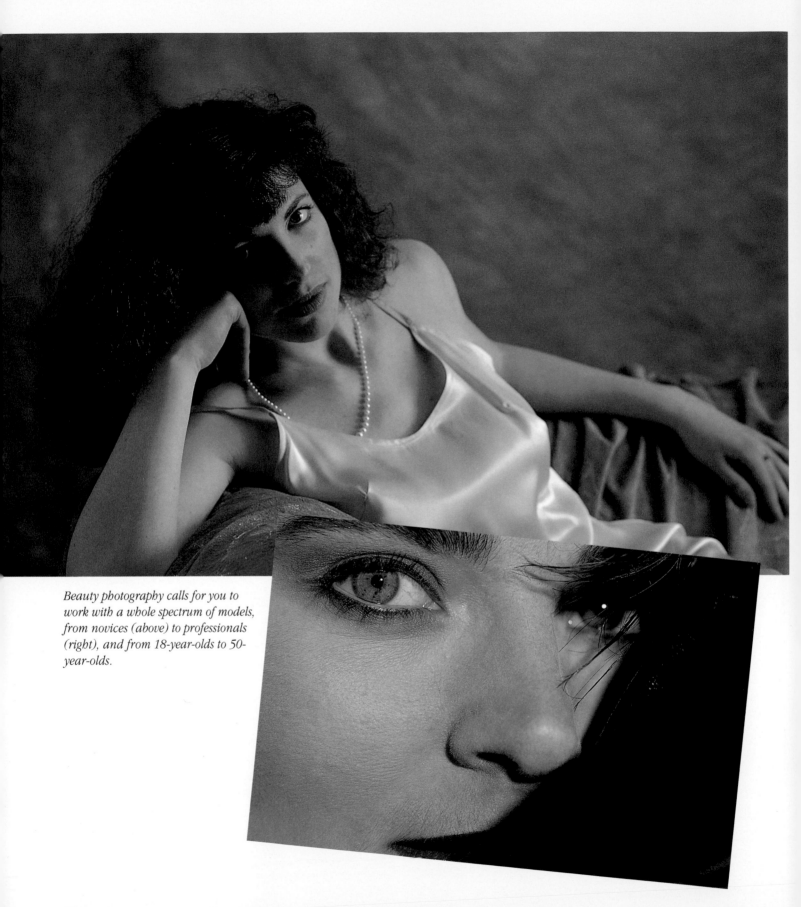

Beauty photography calls for you to work with a whole spectrum of models, from novices (above) to professionals (right), and from 18-year-olds to 50-year-olds.

consider using today. In fact, too many shots of celebrities are just color records of a recognizable face. Far too often, little thought is given to the amount of time that photographers need to create an interesting or commanding portrait. But nothing helps—not the film, not the technique, not even the popularity or notoriety of the subject—if the photographer isn't prepared to make a terrific shot.

Unless otherwise noted, I made all of the photographs in this book with either Nikon 35mm equipment or Hasselblad 2¼ equipment. In fact, I still use my Nikon F3 cameras. Like many other professional photographers, it takes a lot of convincing to get me to change equipment. Some photographers treat particular cameras like comfortable, old pairs of deck shoes! More important, some cameras you use prove themselves to be indestructibly dependable. And the last thing you need to worry about when you shoot a huge production on location or in the studio is your equipment. Furthermore, before I made a major brand change, I would do extensive tests because the cost of replacing 4 camera bodies, 15 lenses, and various filters would be astronomical. However, if the switch gave me more freedom from technology at the moment of shooting, the expense would be bearable.

Adding a new line of more sophisticated cameras to free myself from technology might sound like a contradiction. But to be able to concentrate on just the problem at hand—such as composition, attitude, or movement—without being held back by a piece of equipment is essential. What I'm trying to say is that having to figure out how to operate a piece of equipment while you photograph is counterproductive. When a shoot is working and everything is flowing and the ideas are coming, the last thing you want is to be interrupted by equipment failure and/or the need to continually make camera adjustments.

Although avoiding the new technology may be difficult, it isn't impossible. During the last several years, professional photographers have been bombarded with information about the digitized image, the electronic camera, instant transmission, computer-generated images, and image manipulation. It seemed that the end of the latent image, or film, was just around the corner. For example, President Bush's inaugural photograph was sent to Japan within minutes of his placing his hand on the Bible, thereby beating traditional wire services by hours.

However, while the press utilizes instant-transmission systems, the traditional uses of film are more in demand now than ever before and are continuing to expand.

The business of making photographs for commercial purposes has been going through another period of growth. But for every step forward, there have been two steps backward. The styles of Man Ray, Horst P. Horst, and George Hurrell, just to mention a few, have been rediscovered and repackaged—successfully by some but badly by most. I believe it was Edward Steichen who toward the end of his long career said, "It was amazing how photography had advanced without progressing." In addition to this re-examination and rebirth of styles that were popular several decades ago, photographers are in the midst of an enormous flurry of new techniques and style. There is also a large number of young photographers who are seriously taking a different look at the end result and bending this marvelous medium to suit their own way of seeing.

Perhaps the single, most important aspect of this business is that there are no rules; you are limited only by your imagination. Manufacturers want you to believe that you need to be concerned with only the creative side of photography because the equipment has become so sophisticated. In actuality though, figuring out some of the features on today's cameras is as mindboggling as programming your VCR. But once you've mastered the electronics and started using these cameras as a traditional extension of the way you see the world, the end result, while a little easier to arrive at, still depends on the message that goes from your eye to your brain to the shutter. There are no shortcuts to creativity or success. You simply have to shoot a lot of pictures and learn from each and every experience. After a quarter of a century of shooting, I continue to try to approach each and every situation with a fresh eye.

By and large, the industry tends to set more rigid parameters on the creative process than any equipment shortfall or lack of imagination ever does. Usually by the time a project gets into the hands of an advertising photographer, it has been intellectualized, approved, and test-marketed to such an extreme that it is virtually a blueprint that the photographer must match. So for photographers who operate studios in the major cities in the United States, a fairly large percentage of the images that they include in their portfolios is composed of tests, personal work, and the relatively few jobs where they

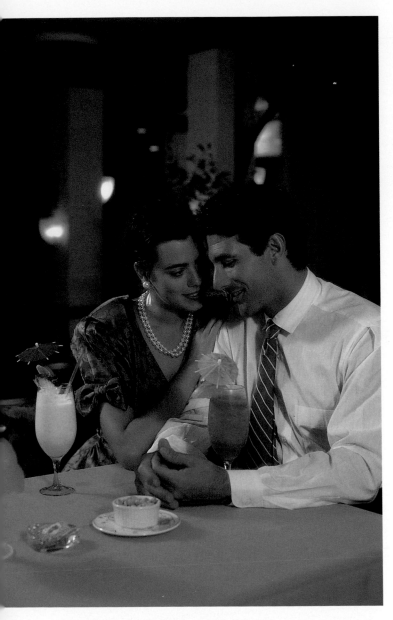

I made this shot for Modern Bride *magazine in a restaurant in Bermuda using a normal lens, a soft-focus filter, and a combination of two portable Norman strobes and ambient light. Although photographing a male model with his jacket on and off usually isn't done in such shooting situations, I covered the scene both ways because some establishments in the islands like the suggestion of informality. I also covered this shot with and without food on the table and with and without a soft-focus filter. Having done a lot of work in the beauty and fashion field, I am particularly concerned that my people shots are properly styled in terms of wardrobe and hair and makeup.*

were hired for what they could contribute as thinking individuals who are able to solve visual problems photographically.

Nevertheless, the number of working photographers with their own viewpoint and style is higher today than ever before. And there actually are photographers who have a specialty within a specialty, such as those who shoot only black-and-white film, or color film pushed to the limit, or pictures of their dog. While many commercial photographers who have been around for a number of years wax poetic about the good old days and wait for the 1960s to return, younger shooters are going off in a multitude of directions and are being accepted. This is one of the most exciting times to be in the photography business; the cross-pollination of mediums is limitless. Computer-generated images, digitized images, and all of the other electronic advances shouldn't be feared but embraced. Several times in the last year alone, I've had to jump in feet first and learn by doing. I realized a long time ago never to say "I can't" or "I don't do," but "I'd love to try."

Finally, as you read *Hot Shots*, keep in mind that the market for straight beauty photography is enormous. The manufacturer of a hair-coloring product still wants to see a package shot of gorgeous blonde hair, and a lipstick manufacturer coming out with five new shades of red wants to see a distinct difference in color rendition. But this doesn't mean that you shouldn't make time to try new ways of seeing or to grow with the medium. After years of using only Kodachrome 25 for nearly everything I shot in the 35mm format and Ektachrome EPR 120, I felt that it was time to look at all the new developments in emulsions. This proved so rewarding that this book is based on these experiments, as they reveal what works for me today in the beauty-photography marketplace.

Still when a job requires traditional beauty photography, that is what I deliver. At the same time, however, I shoot with different films to try to introduce my clients to new directions. Most of the time the response is, "I like the grainy effect, but I think we'll stick with the straight stuff." But several clients decided that it was time to break with tradition and run black-and-white Polapan or very grainy color film. Most important, this experimentation gives me the opportunity to change my portfolio and create newer images.

The quickest road to obscurity for any creative individual is to ignore change, especially when the pace is

as accelerated as it has been in the photography field the past several years. If you have a strong base of technical know-how and the ability to deal with new directions, then I think that you'll find some of the suggestions in this book quite helpful. If, however, you are a serious amateur just starting your own professional career, you'll appreciate the technical information that fully explains how the photographs were made. I also discuss a number of potential creative directions and uses of state-of-the-art film and equipment products that you might want to explore in order to create your own "hot shots."

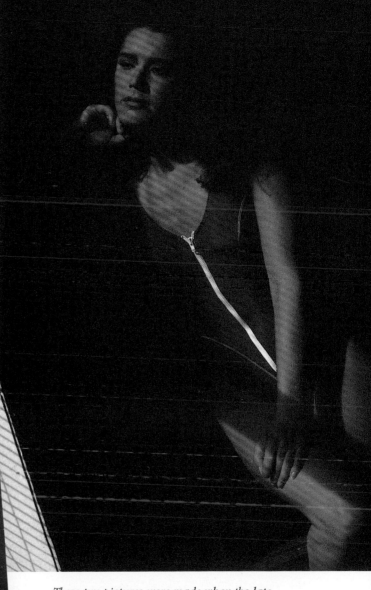

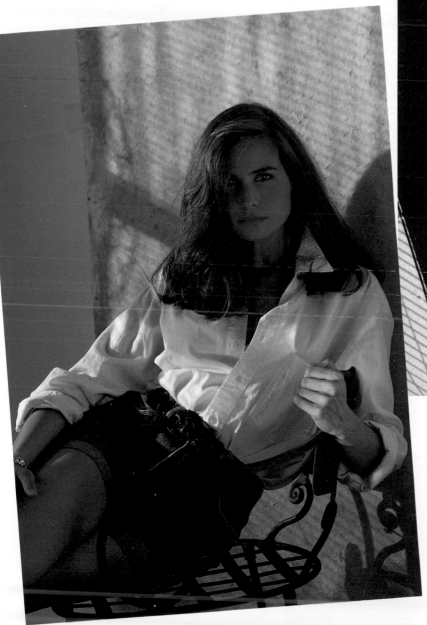

These two pictures were made when the late-afternoon sun filtered through a bank of windows facing west. But because they weren't shot at the same time of year, the quality of the light is different. To provide an interesting background, I had a 4 x 8-foot stuccoed and painted flat placed behind the model. I also used an 85mm Nikkor lens and Fujichrome 100 (left). For the studio lingerie shot, I pushed Ektachrome 100 five stops (above).

Part One
BASIC BEAUTY PHOTOGRAPHY

Professional beauty photographers blend many factors to provide viewers with a page stopper, whether it is an introduction to a specific product, a hairstyle illustration, or a new makeup look. In order to make this come off expertly, you start with a concept or idea, fit the model to the image in mind, and then tailor the model to create that image. While all the parts are of relatively equal importance, good hairstylists and makeup artists can greatly influence the outcome of a photograph. Each of these people brings a different approach to the concept or desired end result, and it is up to the photographer to know which people to use for which project. For the most part, I work with individuals who do both hairstyling and makeup. This arrangement also makes sense because of the bottom-line concerns of agencies and clients. However, some jobs require both a makeup artist and a hairstylist, particularly ones where you photograph several models for one shot.

The wardrobe stylist is another member of the team whose taste and understanding of the desired end product, the photograph, are crucial to the result. The stylist should be able to interpret your desired effect within the parameters of the job. When you look at a potential wardrobe stylist's portfolio, ask how much input he or she had. Was there any freedom involved, or was there a layout with specific directions that had to be followed? I want stylists who listen to the client's requirements, make suggestions, are imaginative, and have contacts. I count on the stylist to be aware of fashion trends and directions that lend themselves to the photograph being produced. This is essential since better hairstylists and makeup artists always want to see the wardrobe colors beforehand, so that they can coordinate skin-tone and makeup colors to complement the look. Stylists not only take care of the wardrobe for the shoot but sometimes are also required to fill in as the producer and bring all the loose ends together.

Although I rely on the makeup artist and stylists for both their skills and their opinions, a shoot is something like a democratic dictatorship. At some point, it is up to the photographer to make the final decisions and to get the show on the road. Regardless of all of the invaluable help—your own staff included—that surrounds you when producing beauty shots, you must have a complete grasp of the lighting variables necessary for creating a beautiful image. If you don't, all the help in the world isn't going to matter. The photographer's input is by far the most important factor in terms of realizing the end result for a number of obvious reasons, such as lighting, exposure, film choice, set or background, and attitude or

expression. The impact of all of these elements can be easily weakened or destroyed by bad lighting technique. Before the shooting, you need to have a clear picture in your mind of how to light the scene in order to pass this information on to both the hair-and-makeup artist and the wardrobe stylist for color selection. For example, if you're going for a very high-key effect, the makeup and wardrobe should mirror that look.

A couple of years ago, I was hired for an enormous lingerie shooting that took place over a two-year period. In order to maintain the best possible results on a continuous basis, my assistants and I tested all of the 120-size color films for range, skin tone, and highlight curve. It was important to carry the detail in the highlight side of the white bra fabric without going too dark on the skin tone. After numerous comparison tests with the three

Ektachrome and Fuji films and several meetings with the creative director and the retoucher, we settled on Ektachrome EPR 64. This film offered both the best images and overall stability. In fact for most of the head shots that I make with a Hasselblad and strobe lighting, I use EPR 64. Of course, during this lengthy project, I had to count on my lab, Aurora, to provide consistent processing; it delivered, never shifting as much as 5ccs (this refers to the color-correction filters used to correct color shifts).

Yet all of the planning involved with a shoot shouldn't prevent you from suddenly deciding on the set to experiment with the lights, such as by changing an angle. Illuminating a scene in order to shoot from one direction doesn't mean that shooting against the light is taboo. Just follow your instincts, and cover what looks good to you at the moment. After all, there is always more film.

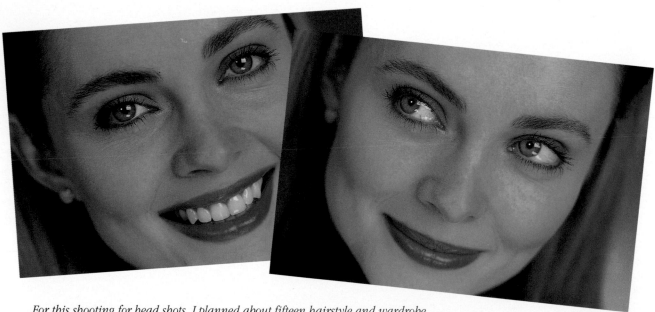

For this shooting for head shots, I planned about fifteen hairstyle and wardrobe variations of this clean-cut, blonde, Midwestern look. The idea behind a shooting session like this is to maximize the end result. I accomplished this by pre-lighting, testing the exposure, and shooting two or three changes per roll of 35mm film, not by bracketing. Simple, clean lighting lends itself to a multitude of illustrations for both editorial and product-oriented advertising.

ONE MODEL, MANY LOOKS

Rather than starting with a "how-to," step-by-step process of applying makeup and styling hair and then showing the various shots that can be found in some women's magazines, I've taken a young woman who isn't a model and transformed her. Sometimes working with a nonprofessional, which I've done many times, is a much greater challenge than working with a model. Transforming a woman who wears little or no makeup and has had the same hairstyle for years is much more rewarding than working with a beautiful subject. Because she is already "packaged," virtually all you have to do is illuminate her well and then make the proper exposure. Although this is, of course, a simplification of the process of working with an experienced model, it is much more difficult to deal with someone unfamiliar with the amount of time and effort that a shoot requires.

The fun part comes when you show the nonprofessional the first Polaroid. The reactions can vary, but usually they are very positive. You're showing someone how glamorous she can look if she wants to, simply by exerting a little effort or by daring to be different and experimenting with a new look or haircut. In essence, you're starting with a clean canvas, and because the subject usually doesn't have a clear idea about how she wants to look, you can dictate the direction of the makeover. Some women will let you dramatically change their hairstyle, and most enjoy having their makeup applied professionally.

I think that any photographer just getting started in the beauty business should try some makeovers. They offer a little more insight into such elements as facial structures, skin tones and textures, and hair types; they also enable photographers to learn firsthand how good lighting techniques can eliminate small problems associated with these features.

With Leah Gordon, the woman I selected for this shoot, it was time to get back to basics again and see what I could do with a fresh face. I had met Leah, who began working for Advertising Photographers of America (APA) directly out of college, while I was on the board of directors of the New York APA. We worked together a couple of times a week, but it was months before I really looked at her. Then I noticed Leah's strong points: her large, beautiful eyes; her full, sensuous lips; and her height. I took a few Polaroids and showed them to hairstylist and makeup artist Jody Pollutro.

This step is important. If a photographer wants to excel in the beauty field, close working relationships with several hairdressers and makeup artists are essential. Most good beauty shots are the result of a collaboration between the photographer, the hair and makeup artist, and the wardrobe stylist. I have a tendency to work with three or four hair/makeup artists and stylists on a continuing basis. I may like the way one artist applies makeup and the way another does hair. A beauty

As you can see in these simple "before" shots, model Leah Gordon is ready for her makeover. Her face is clean and her hair freshly shampooed.

ONE MODEL, MANY LOOKS

To capture one of Leah's "after" looks, I photographed her with a Nikon F3 and an 85mm F1.4 lens on Kodachrome PKM 25. A bank light with four Speedotron heads (for a total of 1,200 watt-seconds) was positioned slightly to the right of the camera; an umbrella on a fill head off to the left and behind the camera was powered at 200 watt-seconds. A dull silver reflector was also used in front of Leah at chest level to fill the area beneath her eyes and nose. The simple painted backdrop was illuminated with another head, also at 200 watt-seconds. Makeup artist Jody Pollutro kept Leah's makeup very clean to bring out the contours of her face. Jody added a bright color to the model's lips for a little drama. She selected earth tones to complement Leah's natural hair color. Then Jody styled her hair to frame her face, using the slight bangs to create a softness.

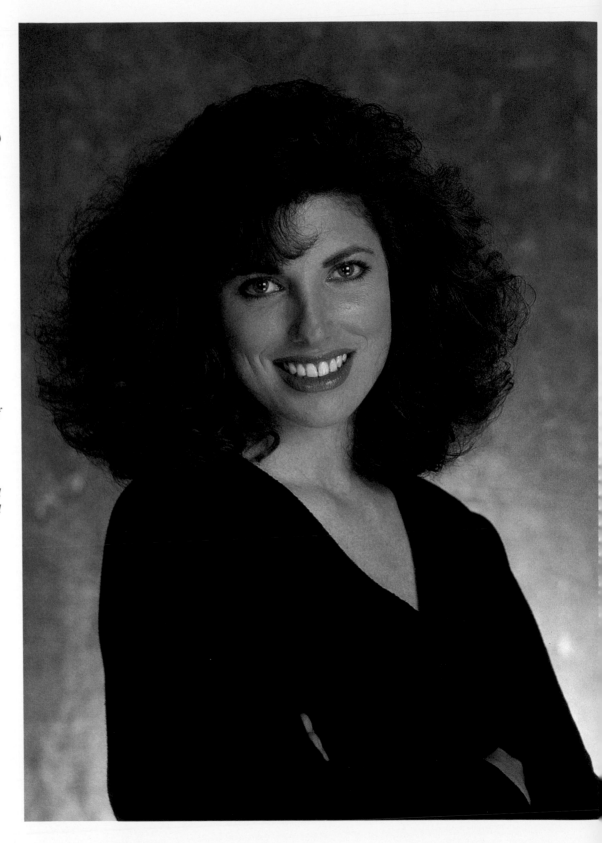

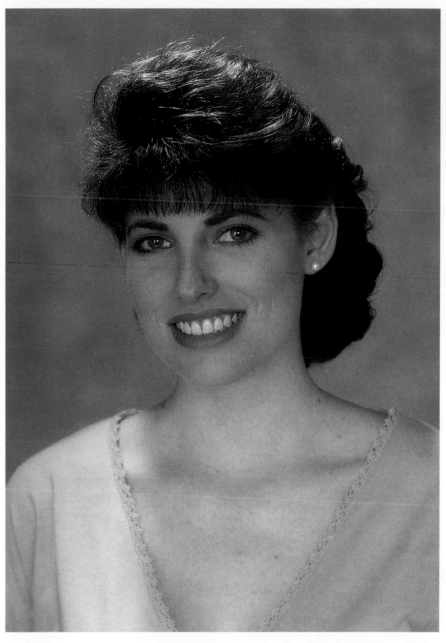

For the second shooting, Jody wanted Leah to have a different, less glamorous look. Starting with soft makeup, Jody used shadow to edge the eyes for definition and added mascara. She kept the lips a pale natural tone. Then she pinned Leah's hair back off her face with a slight roll and tosseled it on top. I kept the lighting soft by tightly grouping three umbrellas around the camera, two on the right side and one on the left; this created a sort of half circle of light. All three heads were powered with a 1,000 watt-second Dyna-Lite. A 200 watt-second head with a focusing grid was used as a hair light to soften and spread the coverage. I had selected a pale blue painted backdrop to complement the subtle color range. I slightly overexposed Kodachrome PKM 25 by half a stop to keep everything pastel.

photographer needs to have a number of people he or she likes and seems to work well with because booking them on short notice isn't always possible. If the people are good at what they do, they're probably working regularly.

Although I prefer certain stylists and hair/makeup artists, I see new portfolios on a regular basis just to stay aware of who is available. Word of mouth is also very important. I call several friends and ask them who they're using and if they're satisfied. If I decide to start using someone new, I always test with them first. If the individual doesn't work out, I want to discover this on my time, not my client's. Portfolios tell only half the story; I'm also interested in the stylist or artist's personality and work habits. Is the person temperamental, refusing to take suggestions from either me, my client, or the model? Most models know what works best for them, such as not using too much eyeliner or wearing a liquid base instead of a powder base, and makeup artists should be willing to listen to these tips.

I asked Jody to check Leah's Polaroids because I trust her judgement. Jody and I agreed that Leah had a good chance at becoming a model and was a perfect candidate for a makeover. Then Jody suggested that the first shooting should be an uncomplicated beauty makeover in order for Leah to get used to working in front of the camera. She asked Leah to arrive with a clean face (no makeup) and freshly shampooed hair. She wanted to create a more glamorous look for Leah based on both the shape of her face and her coloring. A typical makeover takes

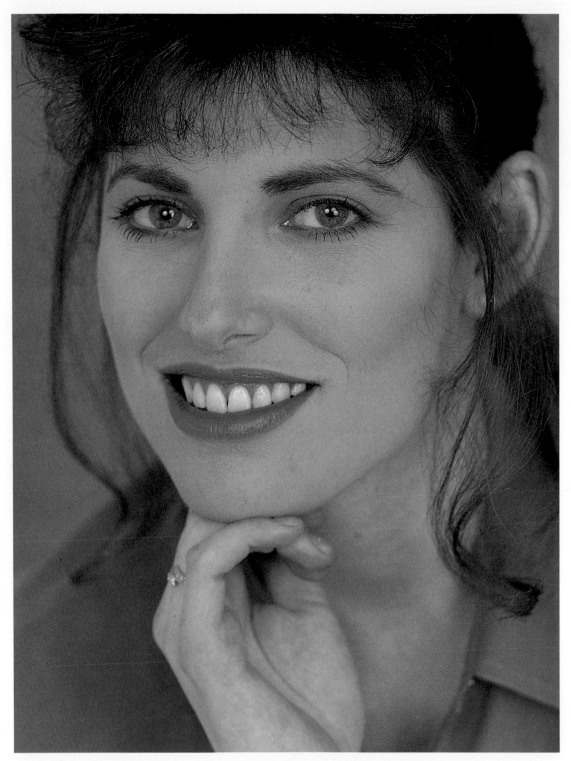

Jody went for a trendier look, twisting the hair up in back with wisps falling on the sides. This created a messy yet more contemporary look—with just a simple change of hair and wardrobe, you have another Leah! I varied the lighting by dropping the hair light and background light.

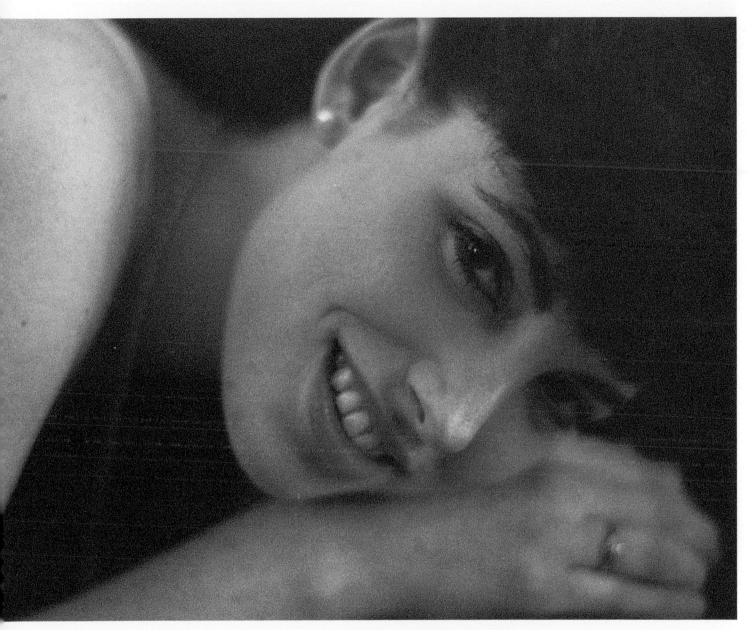

While I was in the process of setting up for a lingerie shooting, Leah came by with some letters for me to sign, so I used her for the test. For this series, I pushed Ektachrome EPN 100 three stops and used only window light to achieve a soft, grainy effect.

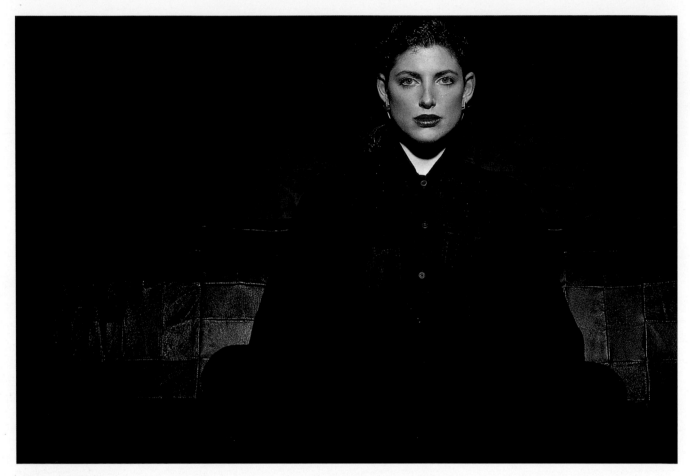

With several shootings "in the can," we decided that it was time for a lighting change; we wanted something more dramatic and trendy. When Leah came in, Nicole Zizelis, my staff stylist/makeup artist/studio manager, did a simple makeup job and then pulled Leah's hair straight back and slicked it down with mousse. Leah had brought a black blouse with her, so we used the black couch as a prop and hung a black background. To capture this black-on-black scheme, I used Kodachrome and a single strobe head with a focusing grid spot to produce a harder light source. Unhappy with the way this washed out the skin tones on the color film, I switched to T-Max 400 and then to Polapan. Since not every face or skin texture can handle a hard light, I ordinarily use it only when this effect is desired for a specific purpose.

For this shot of Leah, I switched to a 180mm lens and Polapan film for the seemingly greater range and detail in the blacks. However, you must handle Polapans with extreme care. If you don't immediately make dupes, you should use glass mounts to protect them.

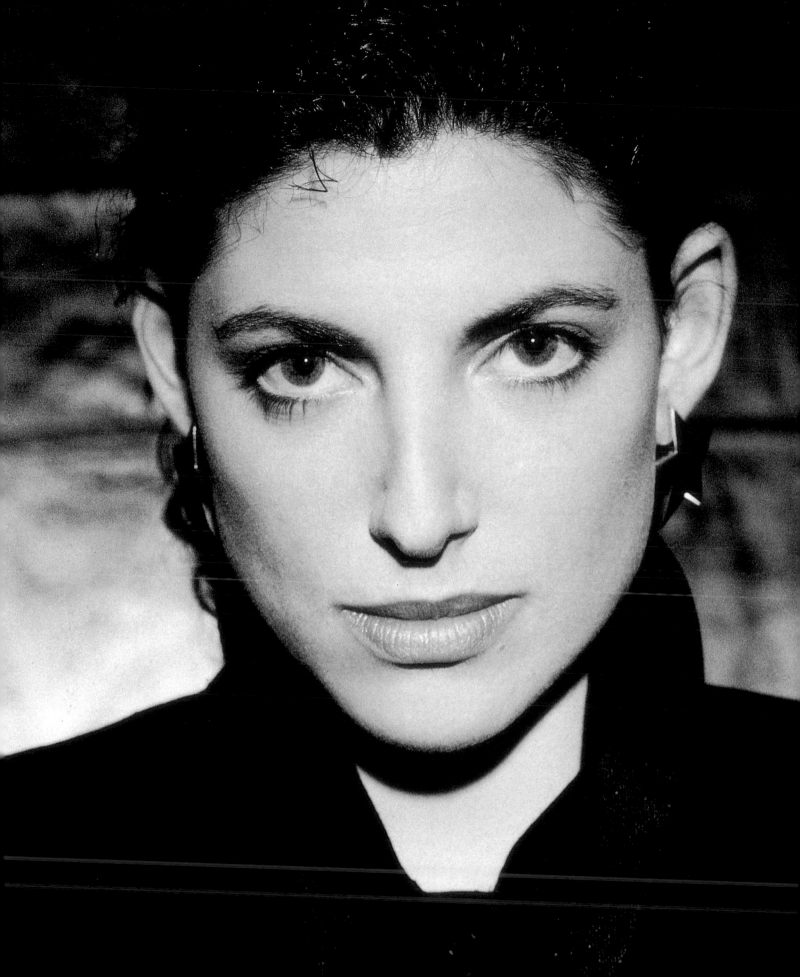

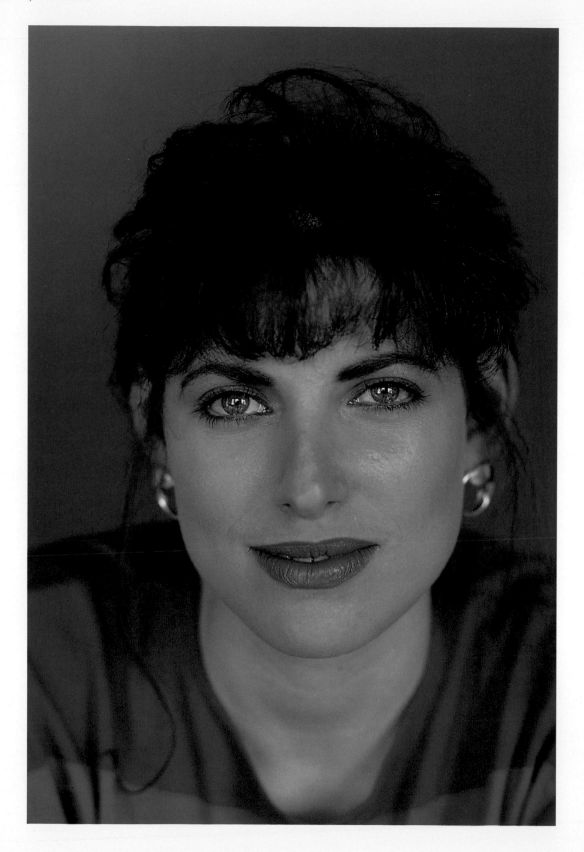

approximately two hours; if a haircut is involved, plan on another hour. Jody usually starts with a base makeup and works from there, adding contours and colors that she feels works with the subject. Depending on the desired end result, she uses eyeliner, eye shadow, and lipstick.

Most of the time, I let makeup artists do the first session based on their knowledge and experience, as well as their feeling about the subject. After the first makeover, I can then go in other directions. I might try pulling the model's hair back or, with permission, trimming it a little. I am sure that no two photographer/hair-and-makeup-artist teams would do the identical makeover on the same subject because the step-by-step process is very subjective. For example, I decided to try several

styles on Leah. Jody and I started with a basic "before" shot and kept the lighting simple. (The first shoot with an amateur is also an exploratory "look-see," during which you learn about the person's facial structure, skin texture, and personality.)

Then I did several shootings—some in the studio, some on location—with Nicole Zizelis, my former studio manager and staff stylist, and Ken-Ichi, a well-known hairstylist/makeup artist. When I talked to Ken, he said that he wanted to create an entirely different approach, one that Leah most likely wouldn't try to duplicate or wear outside the studio. He envisioned a look that was strictly for shooting, similar to a fashion cover shot. Nicci, on the other hand, came by for one shooting and made only simple changes, letting Leah do most of the

makeup application by herself.

As the shooting progressed, Leah became more comfortable in front of the camera and relaxed her approach toward modeling. Each session with a novice is easier than the preceding one. The models begin to understand that they are expected to contribute to the session by being animated, moving gracefully. And since I was interested in having several hair and makeup artists try different looks on Leah, I had planned to use more dramatic lighting as the sessions progressed. By the time we finished the entire series of shots, which took several months because everyone had to fit the shootings into their schedules, Leah had become a pretty good new model—and had learned that modeling can be long and tedious, that it isn't all glamour, which most people think.

Jody and I decided to try for one more look with Leah (opposite page). The more different looks a model has, the more versatile her portfolio, or book, will be. We wanted to use simple makeup and strong colors to emphasize Leah's eyes and make them look more dramatic. Shooting at midday with a macro lens, I had Leah face the bank of studio windows for a broad source of flat light. I switched to Fuji Velvia and shot it at ISO 40 specifically to make the primary colors jump. (Most of my friends who use Velvia rate it at ISO 40 or less; it definitely isn't ISO 50 as indicated.)

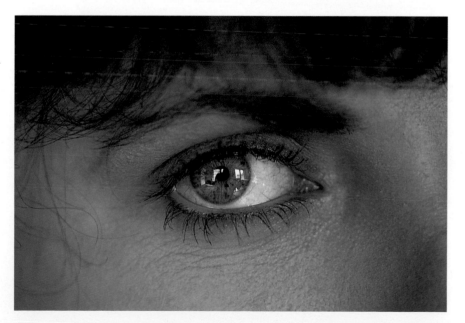

Here, I came in with a macro lens to grab a closeup of Leah's gray-green eyes. They seemed to change with the quality of the ambient light and had a particular sparkle that day.

ONE MODEL, MANY LOOKS

After the studio shooting was completed, I suggested going out in the street to see how Leah liked performing in front of people. We used my favorite alley behind the studio, which is very busy with truck traffic at midday. If models can concentrate on shooting while the various passersby make comments about their anatomy, they pass the test as working New York models. (Leah did pretty well.) I started with a 180mm lens for tight head shots and then switched to an 85mm lens to include more of Leah's body (below). For those shots, the sun bouncing off the side of a white panel truck served as the back light. The film was Fujichrome 100.

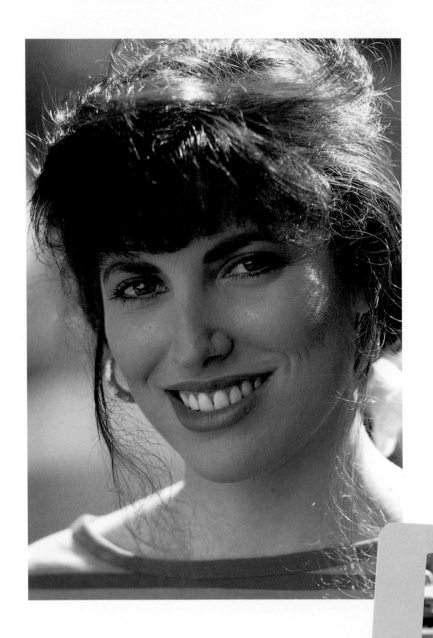

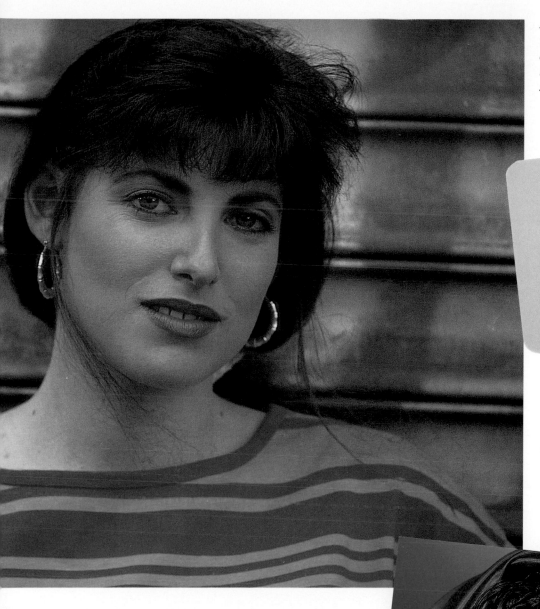

As you can see in this shot in the alley in open shade, Fuji film really shines as it zaps the colors—which is fine as long as you don't mind the warmer skin tones.

For this shot, I pushed Fujichrome 100 two stops to ISO 400. It gains a little contrast and grain but is still very acceptable.

I contacted hair and makeup artist Ken-Ichi, showed him Leah's shots, and asked him what he would do with her. The resulting last session was shot with 120-size Ektachrome EPR 64, a Hasselblad, and a 120mm lens with a 21mm extension tube added for this tight shot. Ken suggested doing a mock European-looking, fashion-cover shot. Because we had been working mostly with warm colors, he decided on a cool range of colors and chose the silk scarves as props. He did the makeup to take a hard light, and I used a single strobe head with a focusing grid plus a diffuser. I hit the background, which was a sheet of blue Formica, with a strobe at the top going from white to blue.

STUDIO BEAUTY LIGHTING

The demands for new looks in studio beauty lighting involve an "anything goes" approach. So I've tested a number of lighting changes, which are shown in this book. However, I still frequently receive requests for clean, well-lit beauty shots. In the studio, I work with a variety of light sources and strobe combinations. But my tried-and-true custom-made banklight, which I've used for years and continue to use about half the time, remains the best light source I've ever had.

A number of still-life and food photographers had a hand in refining the design of such big custom banklights. According to Dick Frank, a major force in food photography, the lights weren't originally designed for beauty shots, but the even quality and true color of the illumination made them a natural choice. My banklight was made from a design Dick gave to a steel-fabricating shop. It showed a 4 x 4-foot aluminum box 12 inches deep with a back section 17 inches deep and angled approximately 45 degrees into a 24-inch-square panel that could hold up to five strobe heads.

The banklight is mounted on a steel yoke that enables me to point it up and down and to swivel it. The yoke is connected to a hollow, 10-foot-tall steel shaft; this shaft, or mono stand, is attached to a 4 x 4-foot steel base that is mounted on 6-inch wheels. Inside the mono stand is a 25-pound counterbalance weight that is connected to the banklight by a series of aircraft cables. This allows me to move the banklight up and down the shaft with one hand. I use only four Speedotron heads in the banklight that has separate modeling lights and a cooling fan. The front of the banklight is covered with a 1/4-inch thick piece of translucent, white Plexiglas. The base carries up to eight 2,400 watt-second Speedotron units that are up off the floor and contained when you move the banklight. This practical feature keeps units out of the way when they're not needed. When used intelligently, this type of design is tremendously versatile. It can even be rotated upside down to serve as a light table that is perfect for shooting.

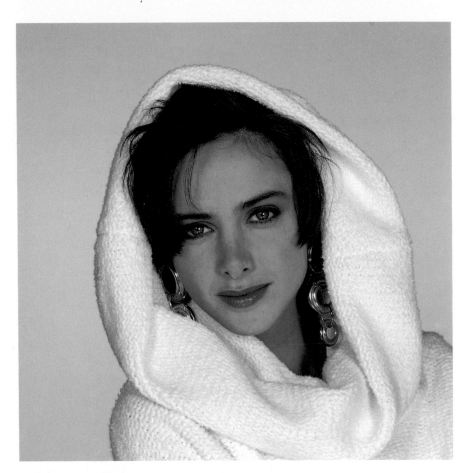

To photograph model Debbie Brett, I used two Speedotron 22-inch reflectors with diffusers, powered by a 2,400 watt-second unit (above). I placed both heads at camera level, one slightly higher than the other. Additional heads were used on the white background, and a silver reflector was placed in front of the model for fill. Then I lighted Debbie with a single strobe head with a focusing grid (opposite page). Canned smoke was used in the background. Two sidelights were added in order to enhance the smoke and edge-light the model. I made this shot on 120-size Ektachrome EPR 64 with a Hasselblad.

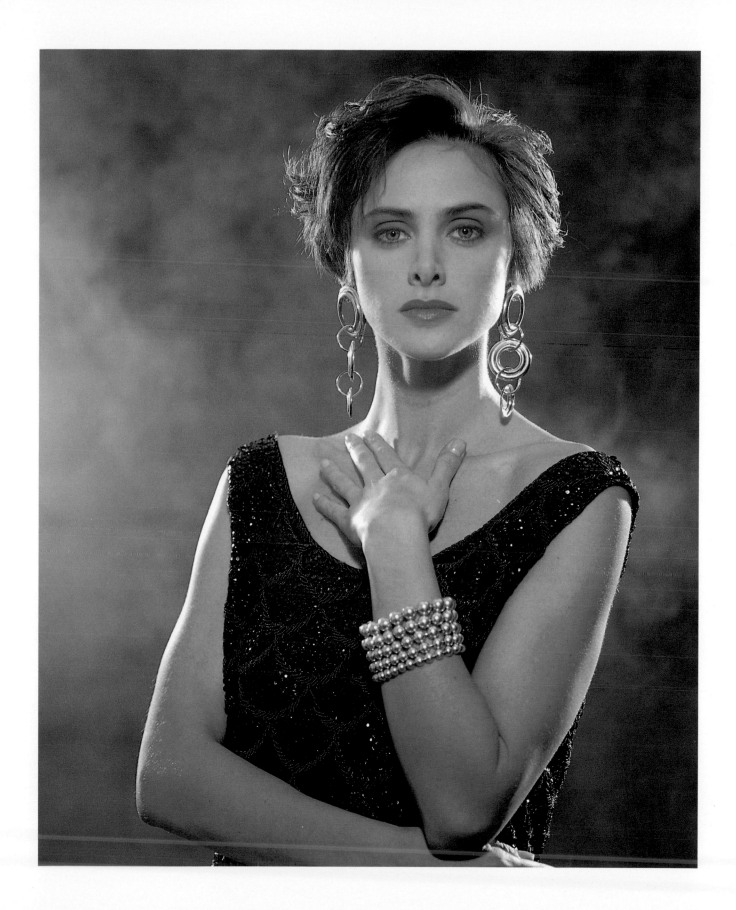

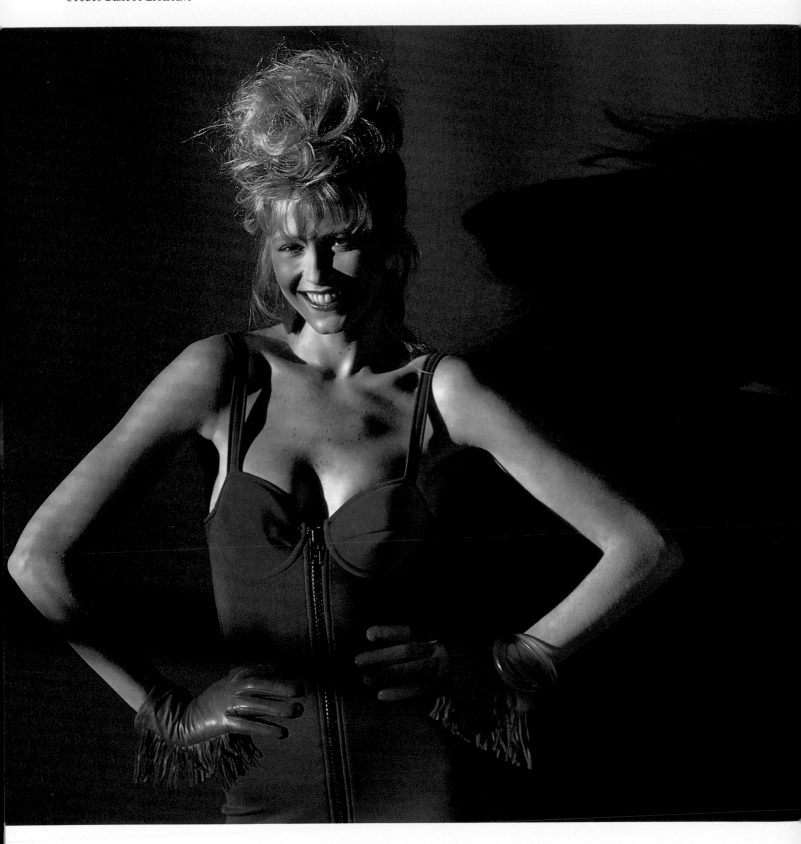

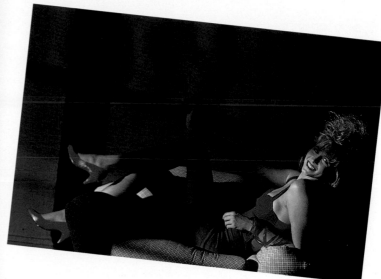

The studio shooting wall had been painted video blue for a video production. Before repainting it white, my staff and I styled a wardrobe for a series of images using only late-afternoon sun diffused through blinds. I photographed Sherri Montgomery on Kodachrome PKM 25.

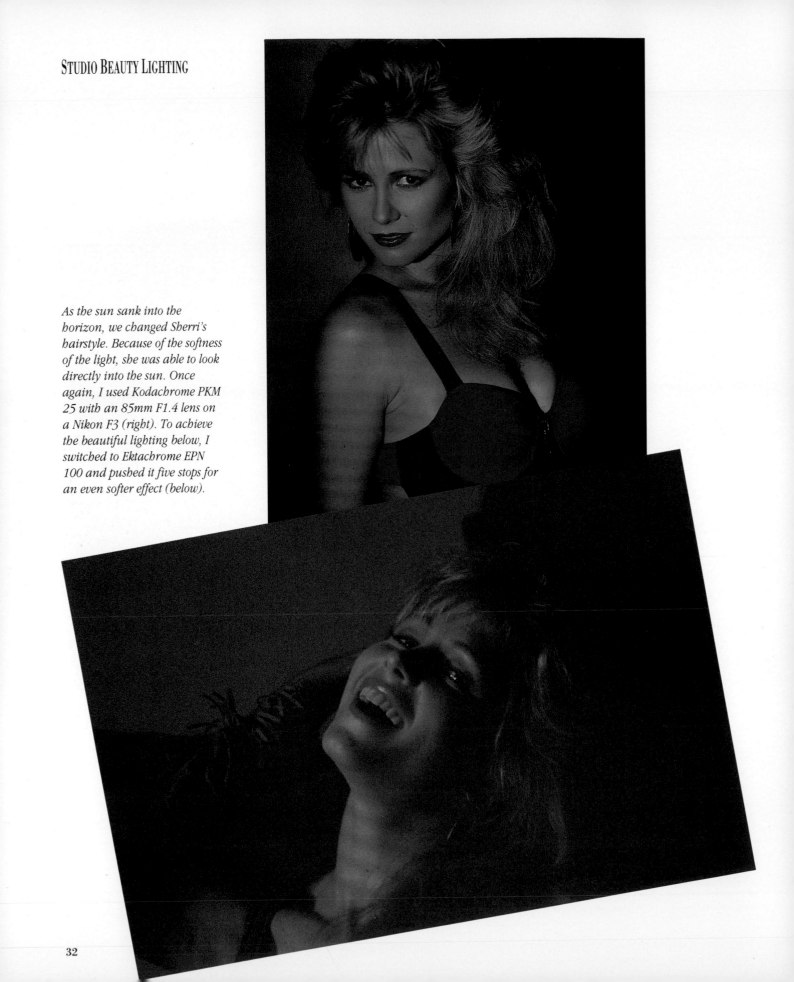

As the sun sank into the horizon, we changed Sherri's hairstyle. Because of the softness of the light, she was able to look directly into the sun. Once again, I used Kodachrome PKM 25 with an 85mm F1.4 lens on a Nikon F3 (right). To achieve the beautiful lighting below, I switched to Ektachrome EPN 100 and pushed it five stops for an even softer effect (below).

Although several manufacturers offer a number of new portable banklights, I have yet to use one that delivers the same even illumination that mine does. A simple test is to shoot a Polaroid directly into one of these units before you decide to purchase it. I can almost guarantee that you'll see a hotspot in the middle and light falloff at the edges. This is caused by the lack of both hard metal planes and angles of bounce in these soft-fabric units. Another drawback is the lack of a base on which to carry the power packs. So each time you move the banklight, you have to move all the units individually. Furthermore, some of these units are sold with very unstable stands.

Custom-made banklights have gone out of favor for a number of reasons. Their size and weight make them strictly studio units, and many photographers don't maintain full-time studios because they travel a great deal or they can't afford them. So their lighting equipment has to be relatively portable. The simplest reason, however, is that there aren't any advertisements or endorsements for these banklights because they are custom made from individual photographers' designs. Also, there is a certain amount of danger in getting locked into one type of lighting. All of your shots begin to look the same because it is so easy to roll the banklight onto the set and turn it on. You should try to experiment with other types of lighting all the time to see how you can do the same shot differently—and, perhaps, better.

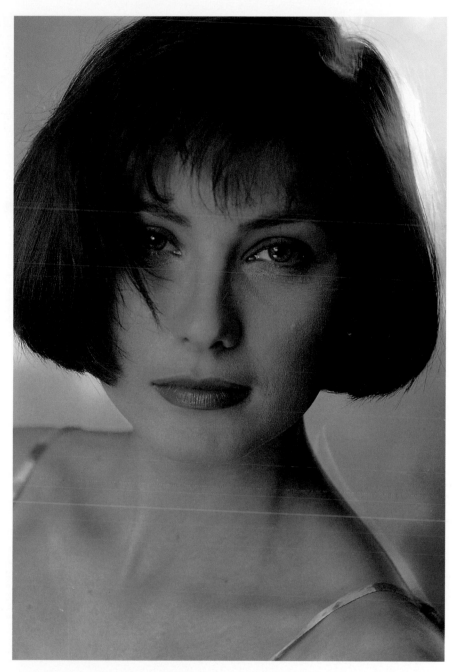

Here, I used a bank light as a sidelight to the left of the camera with a silver fill in front of and slightly below the camera. A tungsten light served as a hair light, and I aimed a strobe at the painted background. Shooting Kodachrome PKM 25 for 1/4 sec. caused the tungsten lighting to be picked up as a slight movement or a diffused ghost image.

Obviously, portable banklights have filled a tremendous void that existed in the still-photography business for years. In fact, you can now rent banklights that are large enough to cover a full-size car. And the increase in the number of rental studios in most of the other major communications centers has created a huge market for portable equipment.

Although I utilize my custom banklight extensively, I've added an entire new line of strobes because of their portability. I've also started to use grid spots, focusing heads, and tungsten spotlights. I wanted both the grid spots and the hot lights in order to have more versatility in using direct or hard lighting for head shots or fashion shots. These are the updated versions of lights used years ago. No "soft boxes" were available during the 1930s and the 1940s, so photographers made their portraits very dramatic via this type of lighting. Most of the Hollywood-style lighting being copied today is shot in black and white, which enhances the effect. And black and white is much easier to manipulate in the darkroom when you make the final prints.

Keep in mind, though, that trends unfortunately have a way of overpowering rationality. So often photographers use the wrong lighting because it is trendy instead of analyzing the requirements for the job and lighting accordingly. There is a time for soft lighting, hard lighting, sidelighting, and moody lighting. One style doesn't fit every assignment. And when a lighting technique is overused, it becomes boring and repetitious; the black-and-white Hollywood-lighting portraits are heading in that direction.

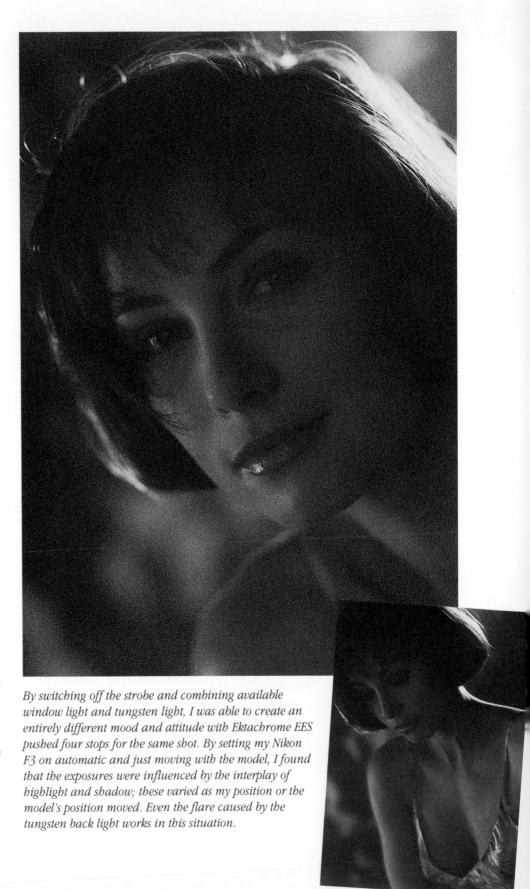

By switching off the strobe and combining available window light and tungsten light, I was able to create an entirely different mood and attitude with Ektachrome EES pushed four stops for the same shot. By setting my Nikon F3 on automatic and just moving with the model, I found that the exposures were influenced by the interplay of highlight and shadow; these varied as my position or the model's position moved. Even the flare caused by the tungsten back light works in this situation.

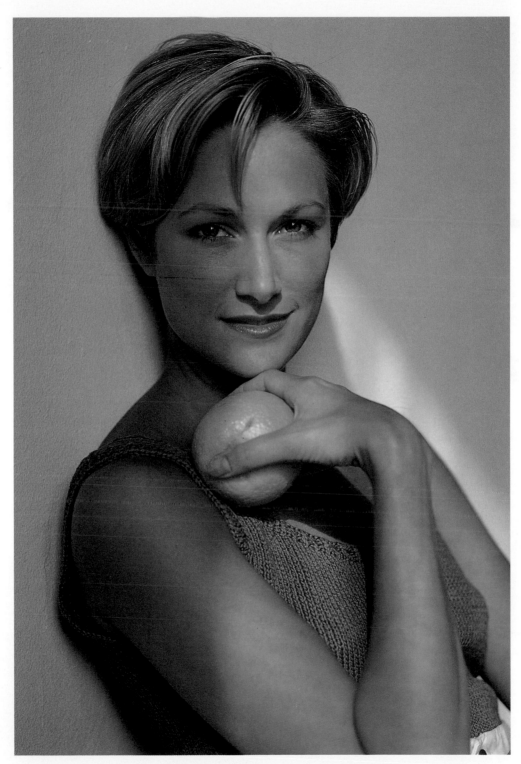

This simple but effective composition was achieved with available light and Kodachrome. Sometimes when a model arrives at the studio for a go-see, I find that her own everyday makeup is more appealing than a glamorous look. Carol struck me that way.

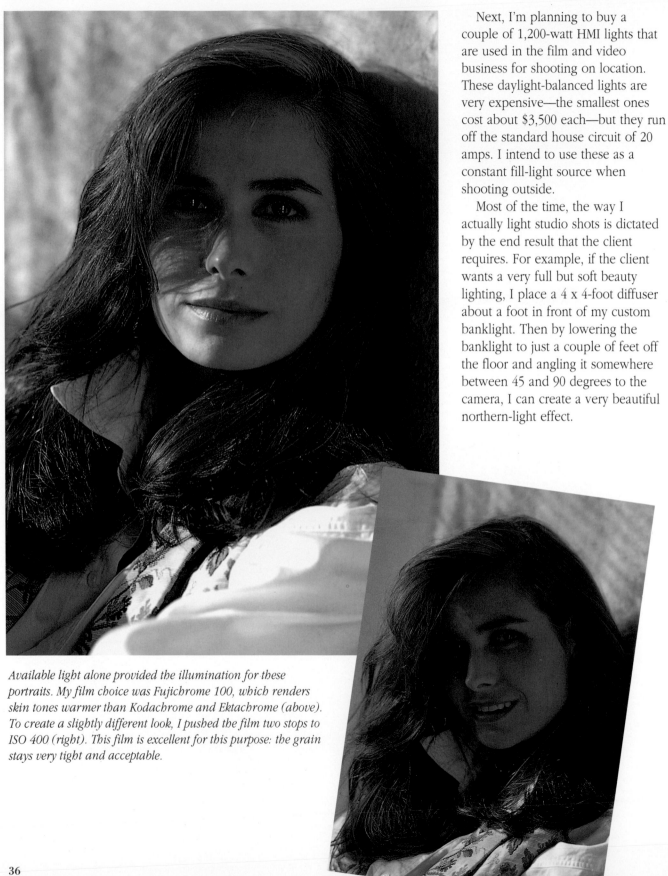

Next, I'm planning to buy a couple of 1,200-watt HMI lights that are used in the film and video business for shooting on location. These daylight-balanced lights are very expensive—the smallest ones cost about $3,500 each—but they run off the standard house circuit of 20 amps. I intend to use these as a constant fill-light source when shooting outside.

Most of the time, the way I actually light studio shots is dictated by the end result that the client requires. For example, if the client wants a very full but soft beauty lighting, I place a 4 x 4-foot diffuser about a foot in front of my custom banklight. Then by lowering the banklight to just a couple of feet off the floor and angling it somewhere between 45 and 90 degrees to the camera, I can create a very beautiful northern-light effect.

Available light alone provided the illumination for these portraits. My film choice was Fujichrome 100, which renders skin tones warmer than Kodachrome and Ektachrome (above). To create a slightly different look, I pushed the film two stops to ISO 400 (right). This film is excellent for this purpose: the grain stays very tight and acceptable.

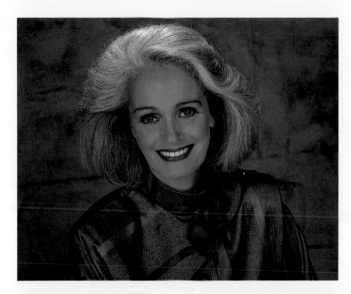

These straight, simple beauty shots of Anita Sklar, an attractive older model, were achieved with very clean studio lighting. This consisted of a bank light off camera right, two umbrellas off camera left, a silver reflector in front of the model, a hair light, and a background light.

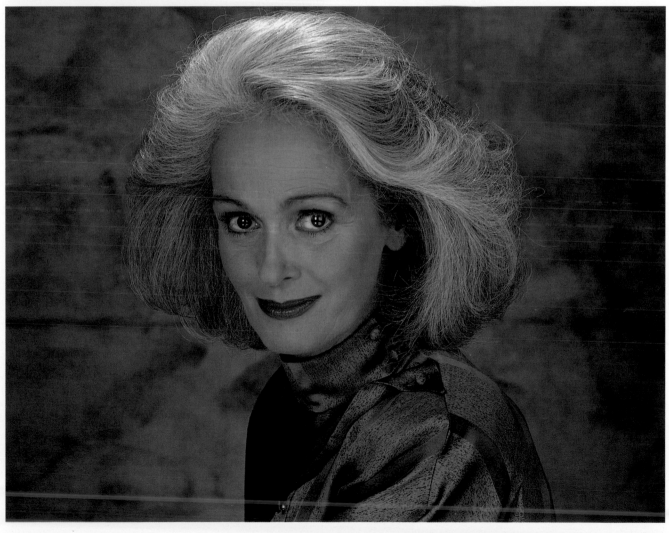

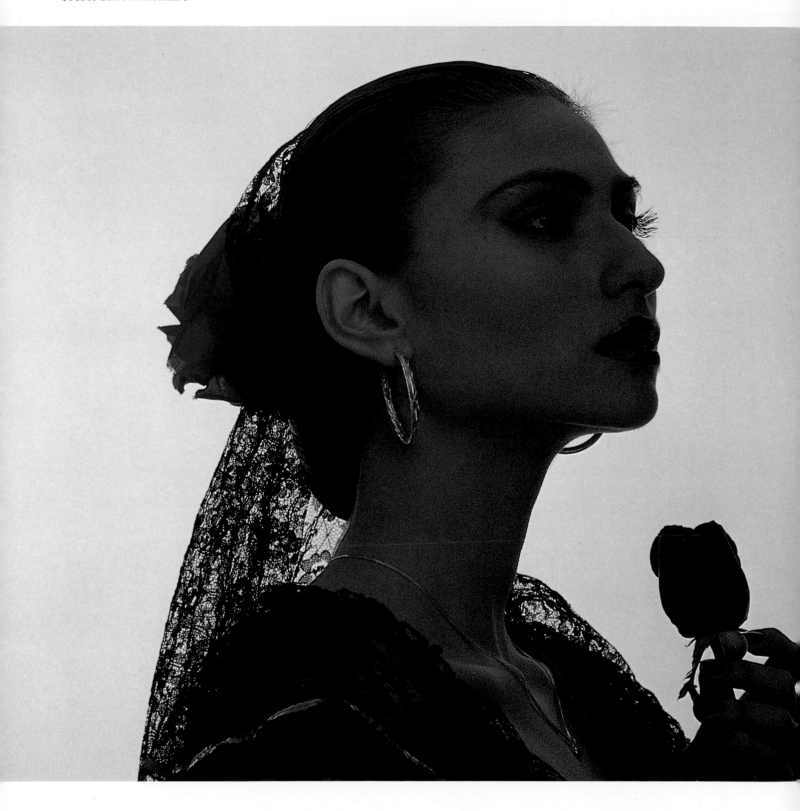

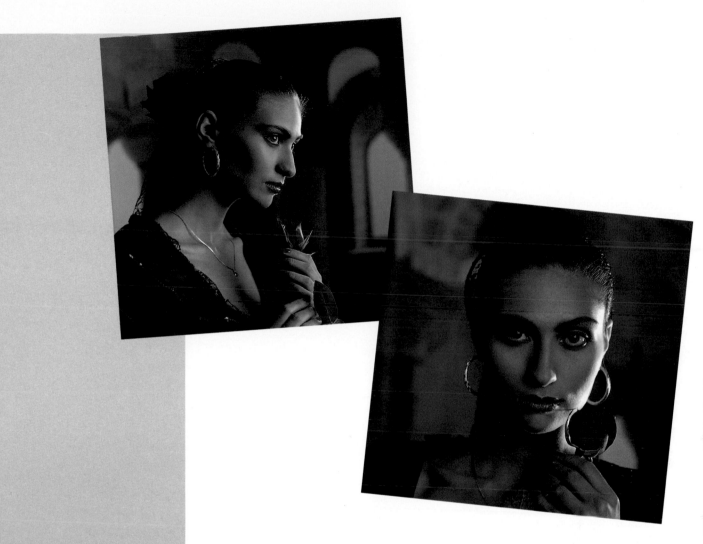

I did a series of images for a poster for the opera, Carmen. The client, Colodny Communications, simply wanted a dramatic shot to illustrate the opera and gave me complete control of casting, wardrobe, and concept. Model Ingrid Pico from Colombia, of German and Hawaiian extraction, was cast because of her wonderful exotic look. Working without a layout, I started by purchasing a book on Carmen, but didn't find it particularly helpful. So having seen the production several years ago, I basically drew on mental images. My very capable studio manager, Nicole Zizelis, handled the styling. The two of us then discussed what I was looking for with hair and makeup artist Jody Pollutro. The shoot produced a number of usable images. These full-color shots were made with Ektachrome 2¼ using the bank light as a strong side light and one strobe as a back light. The painted background, made by Charles Broderson, was illuminated with two strobes through umbrellas. The lighting on the model was goboed off the background to prevent unwanted light from spilling on it.

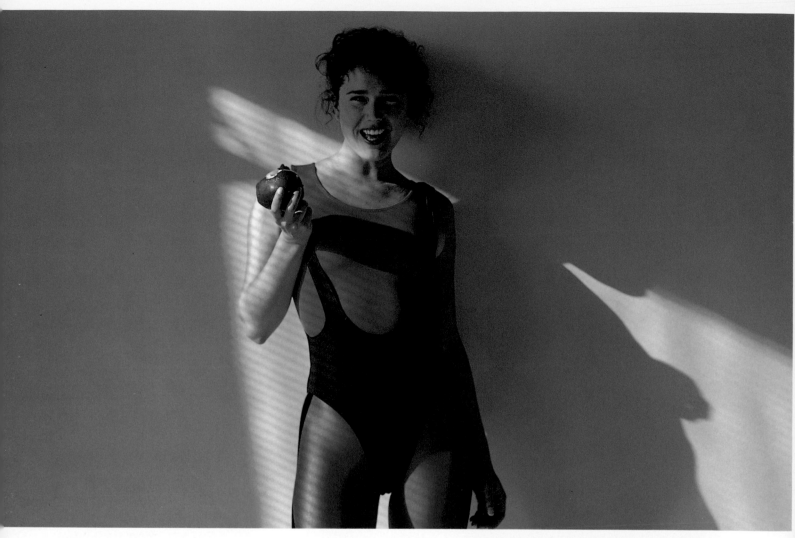

Taking advantage of the late-afternoon light, my staff and I pulled together a stock shot. We decided to go for bright, poster-like colors, and I used Kodachrome to capture them.

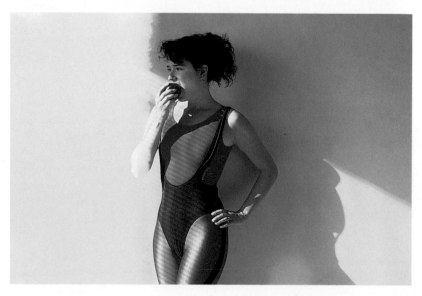

For this side view, I added a strobe light with a yellow gel to increase the saturation on the left side of the background. Shooting for stock requires paying special attention to colors and exposure settings.

As you do more and more beauty photography, remember that your studio lighting is only one of the many tools available to you. Know what you can accomplish with each piece of equipment you own or rent, but don't become a slave to it. Use the lighting techniques in this book as a launching pad; explore how you can take them further or in another direction. Julie Thomas, my studio manager, is a novice photojournalist taking the right step toward learning all about lighting. She worked for a year as an assistant before she became my studio manager, so she was familiar with studio strobes and basic studio lighting. But being familiar with a technique doesn't mean that you're proficient at it. Julie spends most of her free time putting together picture stories, working with one 35mm camera body and two lenses, a 50mm and a 28mm. Having shot about 100 rolls of black-and-white film in available light, she wants to add a small portable strobe and start slowly. Then she intends to advance to larger strobes, and add another camera body and a couple more lenses.

This is the way aspiring photographers started years ago—they learned their craft inside and out. Today, it seems that very few people take this approach. Instead, they want instant success. According to art directors and editors, too many young photographers don't have a full grasp of their own medium. I still believe that the best photographers are also the best technicians. And I find it rather amusing that lighting is regarded as one of the most personal areas that a lot of photographers fiercely protect. If someone is really intent on copying another

photographer's work, figuring out the lighting plot isn't difficult. Furthermore, freelance assistants who work in many different studios always talk about how someone lighted a recent campaign! And for truly innovative lighting ideas, you

can't beat Broadway, the ballet, or the opera. Despite this lengthy, seemingly endless learning process, the studio shoots during which all the variables come together and the energy is terrific to produce great images on film!

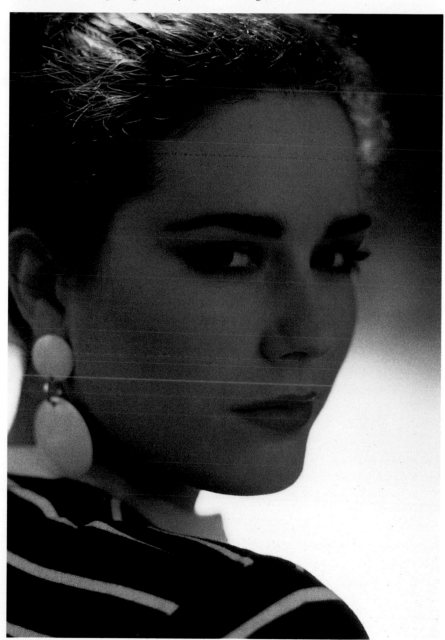

Using Ektachrome EES rated at ISO 1600 with a combination of daylight and tungsten lighting caused the model's skin tone to go warmer in this tight shot. Here, the tungsten light predominated.

BEAUTY ON LOCATION

The percentage of beauty shots I do in the studio versus on location varies each year because of the nature of different assignments, but on average I shoot around 40 percent on location and 60 percent in the studio. Most of the time, working on location is easier, quicker, and more fun. And, providing that the weather cooperates, the bugs don't bite, and no equipment is forgotten or gets lost when my staff and I change planes, location shoots are more stimulating. There is something about new surroundings that gets the adrenalin pumping, especially when the location is exciting. It is also terrific to be out of the confines of the studio and to allow the location to set the tone of the shooting.

One of the best locations in the world for photography is New York City and, in particular, Central Park. Recognizing the vital economic contributions that the film, advertising, and editorial businesses have made, the city helps photographers easily obtain permits for shooting nearly anywhere within its limits. And by compressing space with the tack-sharp, fast long lenses introduced years ago, photographers can shoot a lot of Manhattan scenes that look generic and can appear to be Paris or London.

When my staff and I leave the studio, we call that going on location. But to me, really going on location means getting on a plane with a crew and going to the Bahamas, the Caribbean, or Europe. If we're going to be working primarily outside, I'll bring two Norman 200 watt-second portable strobes with head extensions; several umbrellas varying in translucency; and white, silver, and gold reflectors. In addition, I keep gels and diffusion material in various pockets in my strobe cases. The only times I shoot Polaroids on location are when I'm doing a synchro-sun shot or the client needs a record of the garments I've shot; otherwise, I feel that they slow me down. If people involved with an assignment want to see exactly what I'll be shooting, they can look through the long lens that I ordinarily use. And unless you put the Marty Forscher back (a Polaroid back specifically designed for Nikons) on a Nikon, you won't get the same shot, so Polaroids are pointless.

The advantages of not shooting Polaroids are obvious: not being locked into certain parameters because of strobe coverage, using various angles for a different look or background, and working faster. This, of course, is much better for the models. There is nothing more painful for professional models than a photographer who takes forever to set up each shot and then shoots dozens of Polaroids. By the time the photographer gets around to making the final shots, the chance of any spontaneity has been long lost.

Another of my shooting-on-location practices involves scouting. When I go to an unfamiliar island, I like to scout the area as soon as I arrive, usually with a local driver. Also, I want to know exactly where and when the sun rises and sets. You have to find this out for yourself; if you ask, for example, the driver or a doorman, he'll report the time of the last sunrise or sunset he happened to see, which could have been a month ago.

If at all possible, find out about the location early, during the preproduction phase of the project. A couple of years ago, I tried to convince an editorial client to switch locations, but I was unsuccessful. Although Jamaica is lovely to visit, it isn't my favorite place to shoot. A small mountain range runs east and west along the center of the island. Nearly every afternoon at around 3 or 4 P.M., clouds form as the sun starts to sink behind the mountains. What this means is that you don't get any lovely early-morning sun or golden late-afternoon light unless you shoot on the Negril side of the island. Knowing such little gems in advance really helps.

In fact when I'm about to go some place that I haven't been before, I call a handful of good friends and fellow photographers, such as Larry Dale Gordon, Paul Barton, or Harvey Lloyd. For example, if I'm travelling to a new island, I'll ask them about the best beaches, the color of the sand, the existence of hotels on western beaches (to capture sunsets), the possibility of getting coffee and rolls and a lunch to go from the dining room at 6 A.M., renting a van, and borrowing an ironing board. These are more important to me than knowing whether the food is good and the rooms are terrific.

This is another shot made against the wall in the alley behind my studio. In the afternoon the sun bounces off windows on the opposite side of the street and produces a spotlight effect. I chose Kodachrome 64 because of the low intensity of the light.

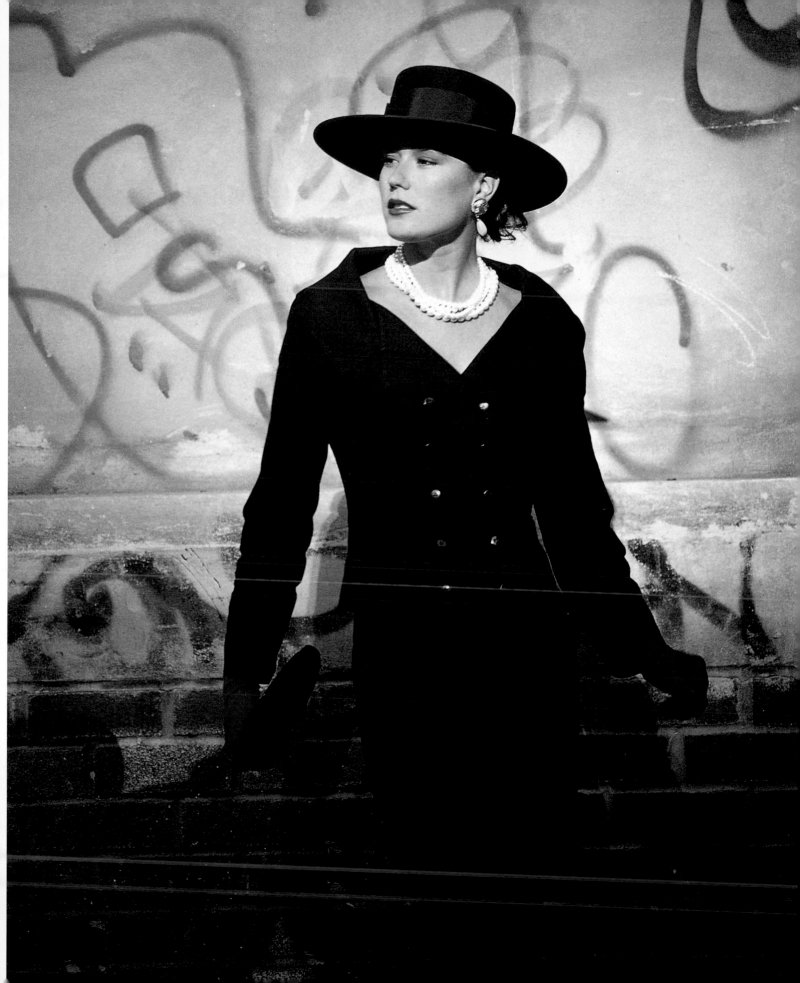

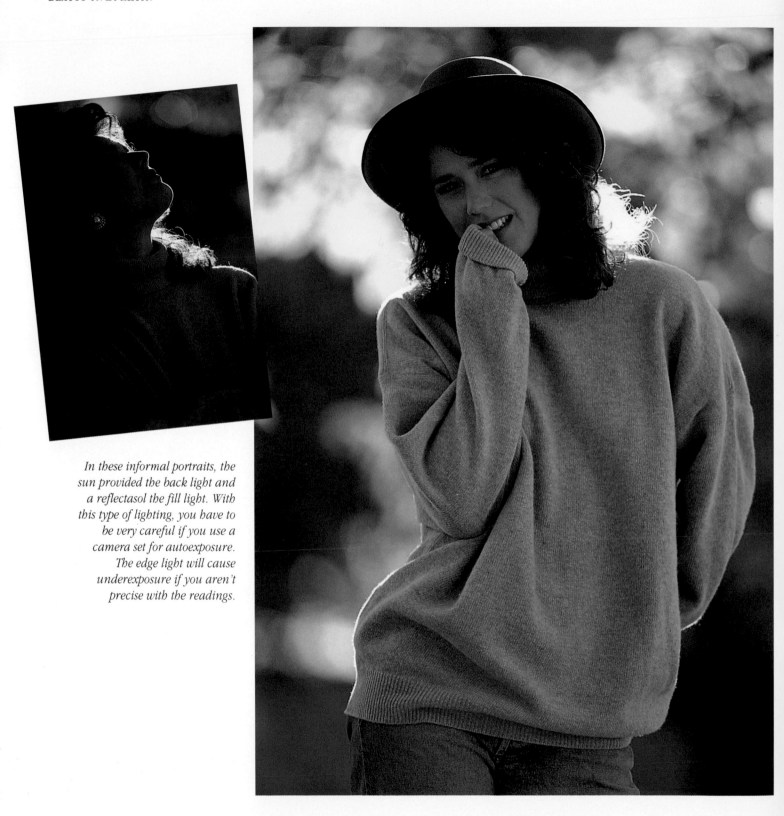

In these informal portraits, the
sun provided the back light and
a reflectasol the fill light. With
this type of lighting, you have to
be very careful if you use a
camera set for autoexposure.
The edge light will cause
underexposure if you aren't
precise with the readings.

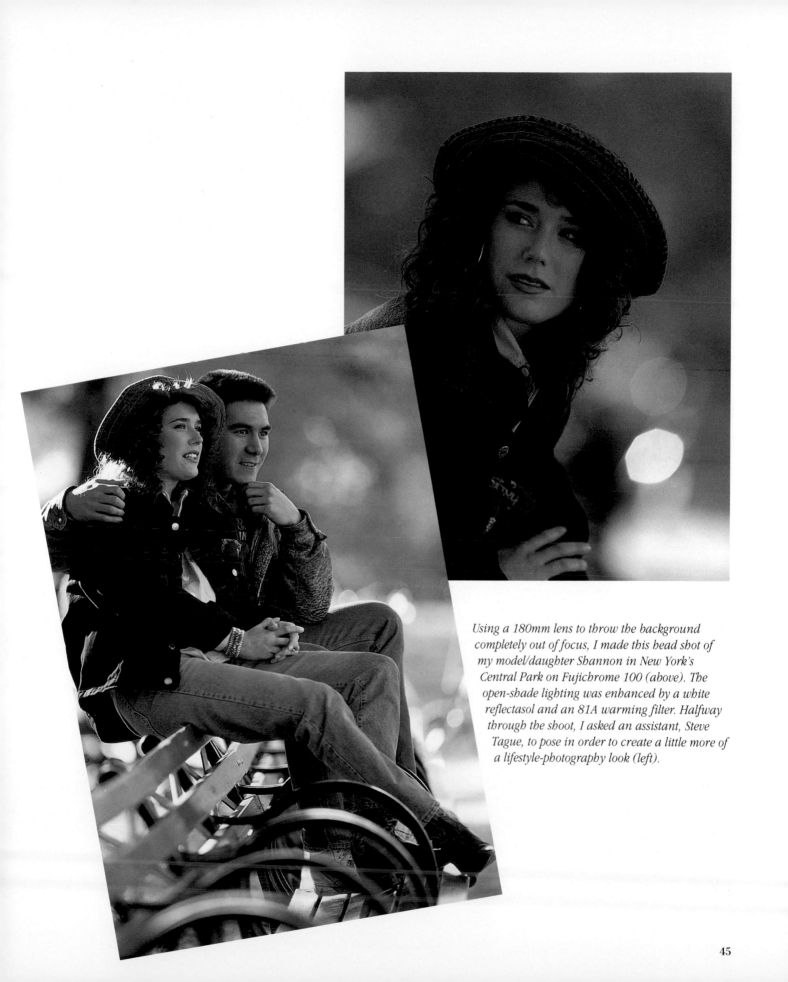

Using a 180mm lens to throw the background completely out of focus, I made this head shot of my model/daughter Shannon in New York's Central Park on Fujichrome 100 (above). The open-shade lighting was enhanced by a white reflectasol and an 81A warming filter. Halfway through the shoot, I asked an assistant, Steve Tague, to pose in order to create a little more of a lifestyle-photography look (left).

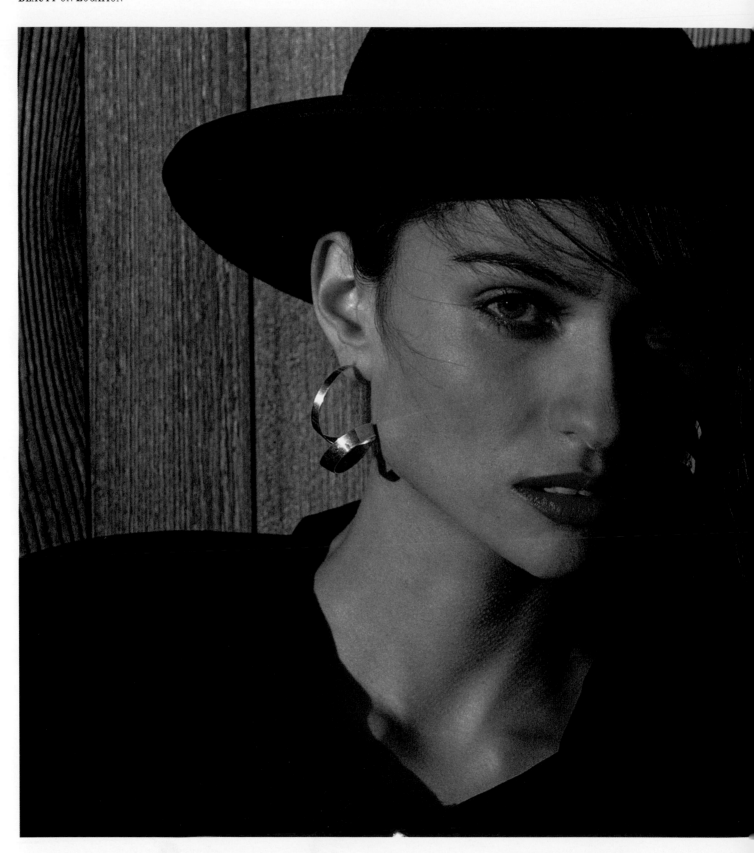

Shooting during the late afternoon, I used the direct sun almost as a portrait light in order to increase the drama and design feeling of the photograph. The result is nearly a monochrome effect with the red lipstick as the accent.

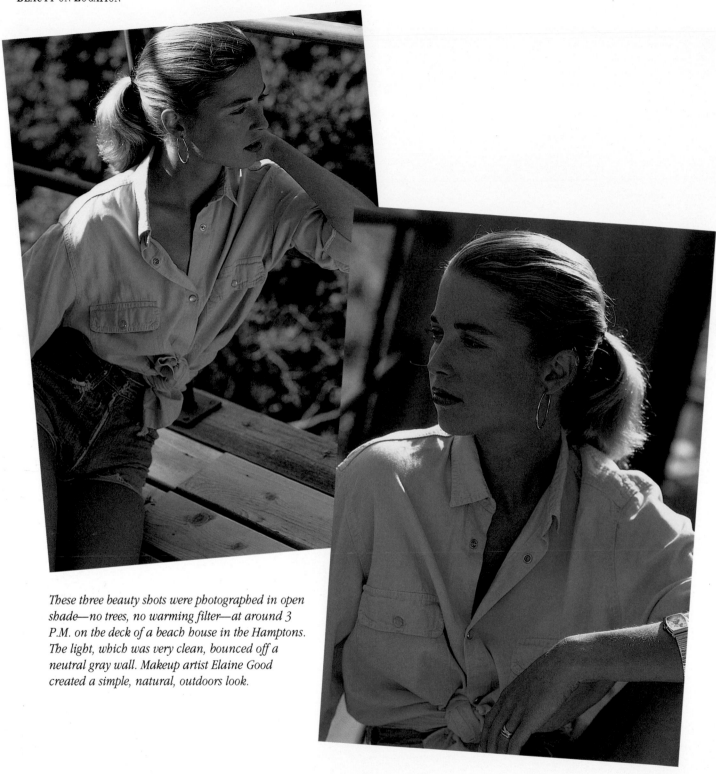

These three beauty shots were photographed in open shade—no trees, no warming filter—at around 3 P.M. on the deck of a beach house in the Hamptons. The light, which was very clean, bounced off a neutral gray wall. Makeup artist Elaine Good created a simple, natural, outdoors look.

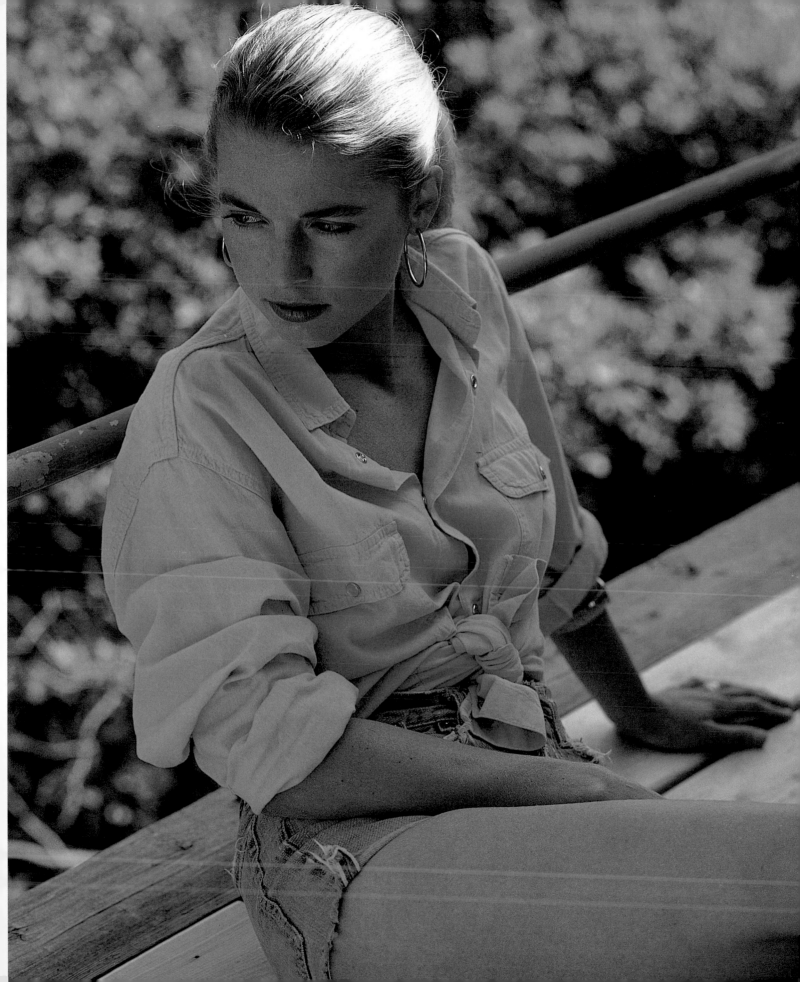

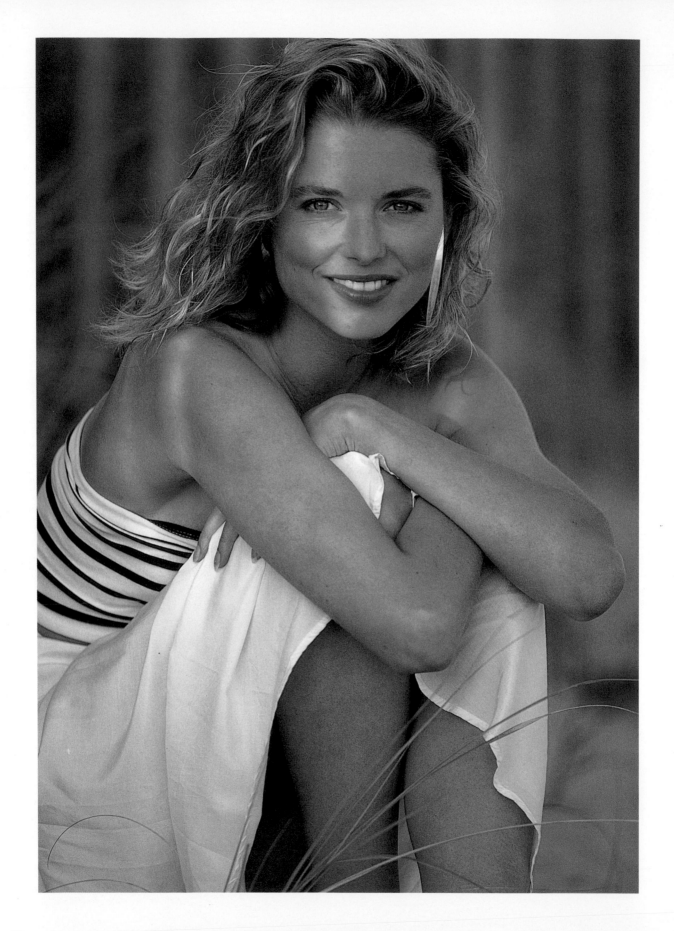

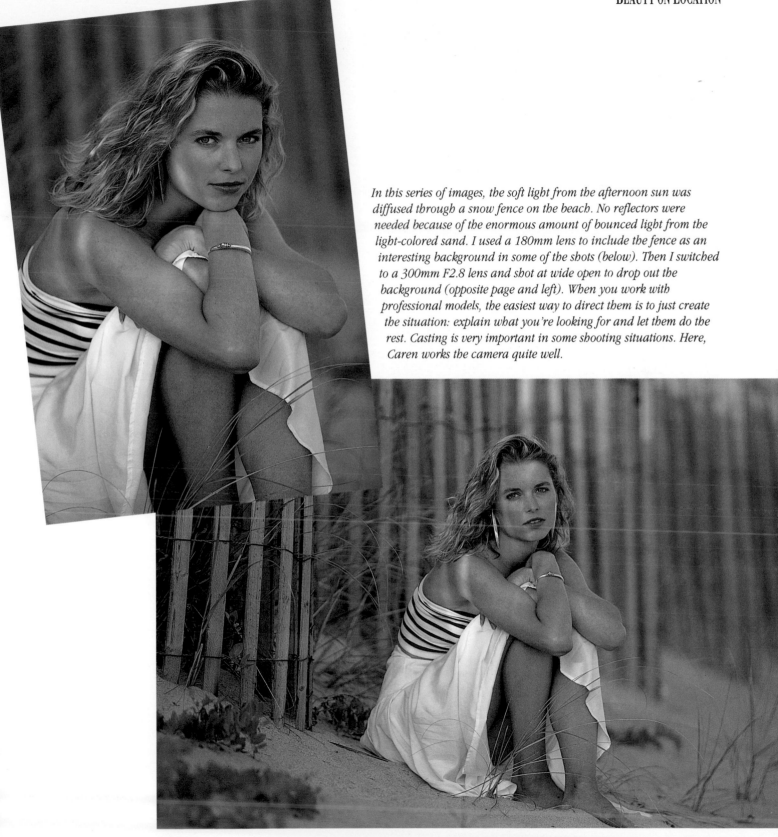

In this series of images, the soft light from the afternoon sun was diffused through a snow fence on the beach. No reflectors were needed because of the enormous amount of bounced light from the light-colored sand. I used a 180mm lens to include the fence as an interesting background in some of the shots (below). Then I switched to a 300mm F2.8 lens and shot at wide open to drop out the background (opposite page and left). When you work with professional models, the easiest way to direct them is to just create the situation: explain what you're looking for and let them do the rest. Casting is very important in some shooting situations. Here, Caren works the camera quite well.

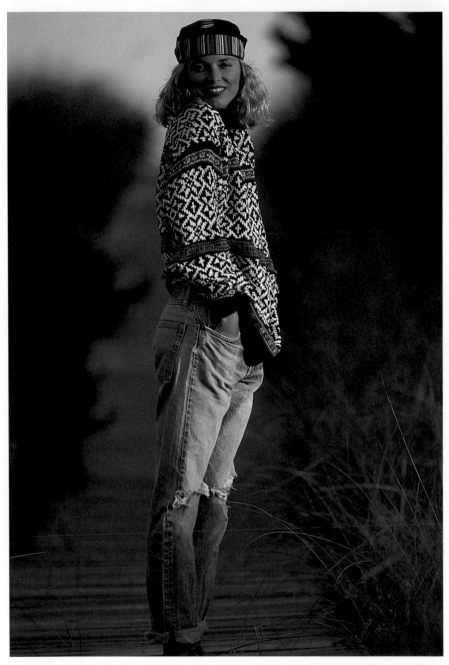

Catching the very last rays of sun, I used a 180mm lens at wide open and exposed primarily for the sidelighting in these two informal shots. No reflectors were used because fill wasn't needed or wanted.

The process of selecting the location can be either very simple or very complex. The difference between working on an editorial job and working for an ad agency greatly affects the decision. Most of the editorial locations I photograph are directly related to the magazine articles or come with a full or partial freebie, such as a place to stay or access to a private beach, that the magazine received. Once everyone is at the location, I decide where to shoot the actual images. On the other hand, I've been involved with advertising jobs in which three different location scouts in various states searched for just the right scene. Scouts usually shoot color-negative film, use one-hour processing, and then put together elaborate folders on each area, noting the directions and time of day. Next, they send this material over to the ad agency for the account people to approve, who in turn seek client approval.

One of the location requests that I've been asked to fill was "a beautiful deserted beach with guaranteed surf and sunshine" for a Sea & Ski ad. My original suggestion, Hawaii, was turned down because it was too expensive. I was then told to think of something in the Caribbean. I explained that there really isn't great surf in the Caribbean, but a beach on the western end of Puerto Rico would be passable. That is where we ended up shooting; the surf was mediocre, but the beach was deserted (in the Caribbean, any surf is always on the western side of an island).

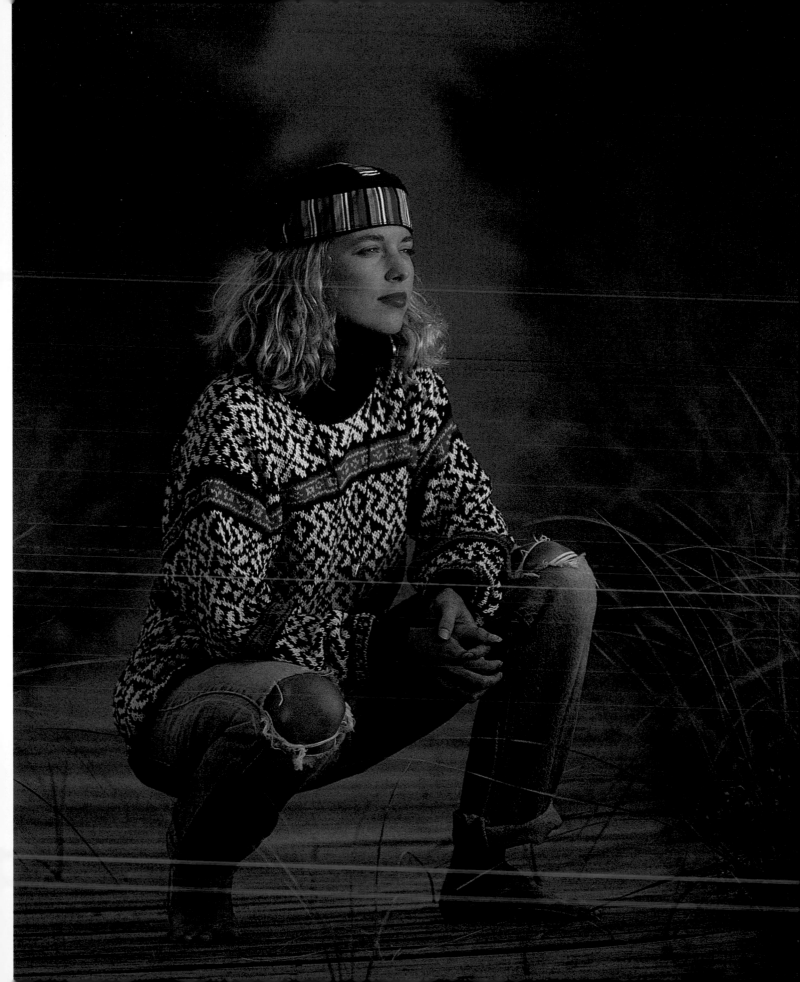

Recently, I received a request for a beautiful, old restored town with a main street that runs west into the beach or water for a sunset shot. I tried scouts in Florida, but almost all beaches there have condos, hotels, or houses on them. Having grown up on Cape Cod, I knew that most main streets on the water run parallel to the bay, not perpendicular to it. Eventually, we settled on two towns in northern California, one that a scout found and one that I remembered driving through several years ago. Unfortunately, when the expense of moving models up there from San Francisco was added to the cost of my crew, the agency people, and me flying there from New York City, the entire project was cancelled because it was much too expensive.

Obviously, planning a location shoot requires much more than simply picking a place that sounds nice in brochures. And don't forget that shooting outside the United States involves getting your equipment through Customs. The smaller the country, the harder this is. Canada and the Middle East pose the most problems, followed by the Bahamas and the Caribbean. Look into the situation ahead of time, and make several lists of your equipment. Some should include just serial numbers, and some should contain both serial numbers and prices. Be conservative when it comes to the pricing because you or your client may have to post bond based on the total value of your gear. If you are about to shoot a major production, check with U.S. Customs to see if you need to obtain a carnet that guarantees any government that when you leave the country, you'll take out any

equipment you brought in with you. This official U.S. document makes going through Customs much easier and can be used in place of the security deposit that many countries demand. A carnet isn't an insurance policy, nor does it reimburse you for equipment. The cost varies according to the value of the equipment involved. There is also a filing fee. A carnet is valid for one year.

Sometimes the crew and I settle on one great beach area for a full day; other times, we work in 10 locations during the course of a day. You have to be ready to work on the run the entire time, in all kinds of lighting conditions, including open shade, full sun, and strobe fill. You also have to consider all of these possibilities when planning a location shoot. Another requirement is keeping your eyes—and your mind—open. For example, on Barbados, the editors didn't see anything interesting in downtown Bridgetown, but I noticed a number of wonderful walls with years of peeling paint on them. I knew that with a long lens, they would make great backgrounds. Also, everyone has to improvise while on location. Hairstylists might have to work without electricity, and makeup artists might have to use whatever light is available. Most models develop a talent for making a complete wardrobe change in cabs, vans, and doorways or behind a reflector or a towel. And assistants have to use their creative resources to provide for everyone.

My major requirement for assistants working with me on location is paying constant attention to the changing light and making careful readings. I seldom ever use the

"auto" setting on my Nikons; I prefer continual readings. After assistants work with me a while, they know what I want—and what I don't want: assistants standing on the beach taking a backlit reading while wearing a white t-shirt and not being concerned about the light bouncing off their bodies onto the meter! Taking proper readings is the single most important technique I expect from anyone who works for me. With the advent of automatic cameras, it is the one aspect of the job that too many photographers take for granted; then they can't understand why half of their film is over- or underexposed.

For on-location shoots, the size of the crew and the amenities are directly related to the budget. Editorial assignments usually provide less time and money than advertising projects. Their bigger budgets cover more expenses and extra help; however, this doesn't guarantee better shots. Frequently, spontaneity produces some of the best photographs. I often find myself saying something like, "Quick! Stop the van! Look at that old building. Let's put that fuchsia bathing suit against that green wall and use a 300mm!" I don't know exactly how many times this type of situation has occurred, but it always works for me. Despite all of the details and potential problems, I still find working on location more exciting than shooting in the studio week after week.

This fashion shot was done during the middle of the afternoon in direct sunlight. Shooting Kodachrome with an 81A warming filter and a polarizing filter made the white coat really posterized against the sky.

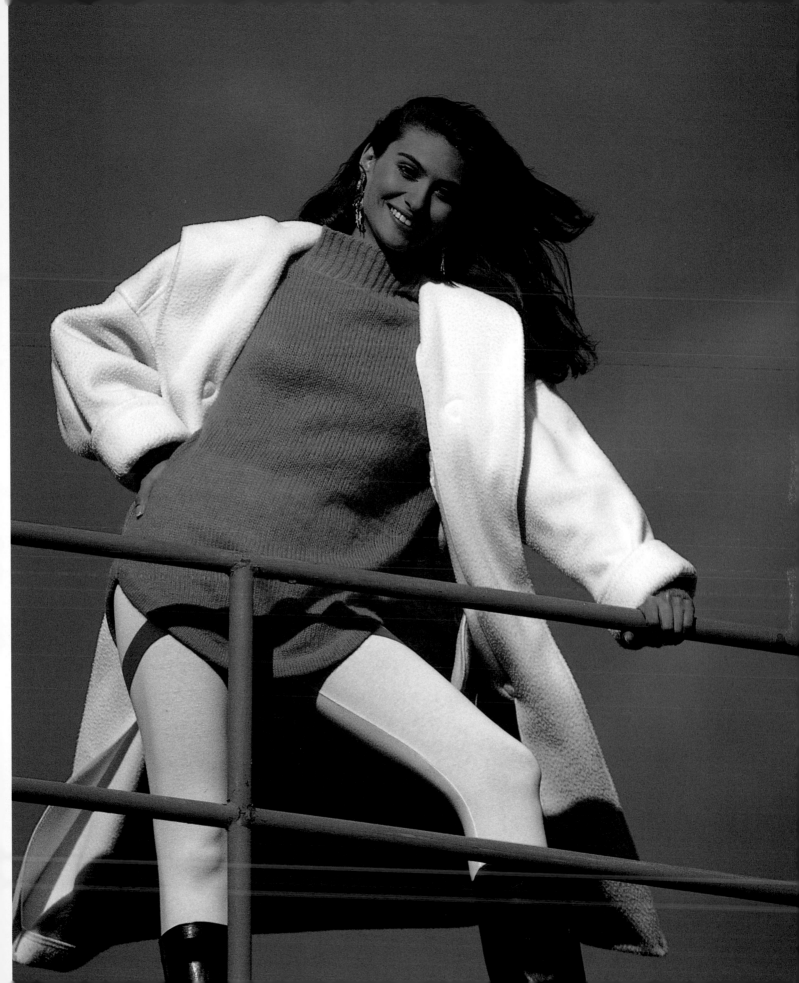

EXPERIMENTING WITH LINGERIE

Shooting lingerie is one area of beauty photography where you're sometimes asked to shoot according to strict specifications the packaging and then allowed to stretch the limits with the same product for advertisements. I've had to shoot an article of lingerie three ways: one for packaging, one for domestic advertisements, and one for European divisions that are more receptive to sensuous treatments.

For point-of-purchase displays, every client I've worked with wants to see the lingerie photographed in detail because potential customers want to know exactly what the product looks like. Is it pretty? Is it lacy? Does it have a clasp in front? But for advertisements, you may be asked to convey a specific mood or to capture a look of femininity or sexuality. Lovable Bras, a Mexico-based lingerie manufacturer,

requested a feminine look, but on the whole, the shoot was pretty loose. The client came to New York City in order to choose from the wide range of models available. All of the sets were pulled together from existing studio props, primarily from my large selection of painted backdrops. Stylist Jocelyn Braxton borrowed designer bed linens from the manufacturers. We all agreed on using flowers because we thought that they went with the look. Again, I used 120-size Ektachrome EPR 64 film and my Hasselblad. In addition, at the end of each session, I shot a couple of rolls of Fuji 100 as an alternative.

In order to squeeze in eighteen shots in three days using one model each day, three simple sets were put together. And because we had to use each model on each set, Ken-Ichi had to create three looks for the models, Sharon Proto, Heidi King, and Kim Forbes. This is when working with professionals and proper planning pay off; the shoot went like clockwork. Only subtle changes to the flowers and props were made to help differentiate between the models and the various product lines. Background lighting adjustments were also made. For example, cast shadows and gels were added. For this job, I brought in John Bourke, who is particularly talented in stage lighting. This set was built next to the windows to utilize the combination of available light and strobe. A 2K spotlight was also used on the painted backdrop. I shot 120-size Ektachrome EPR except where noted.

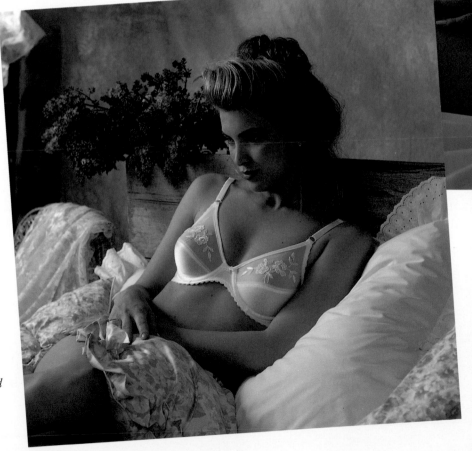

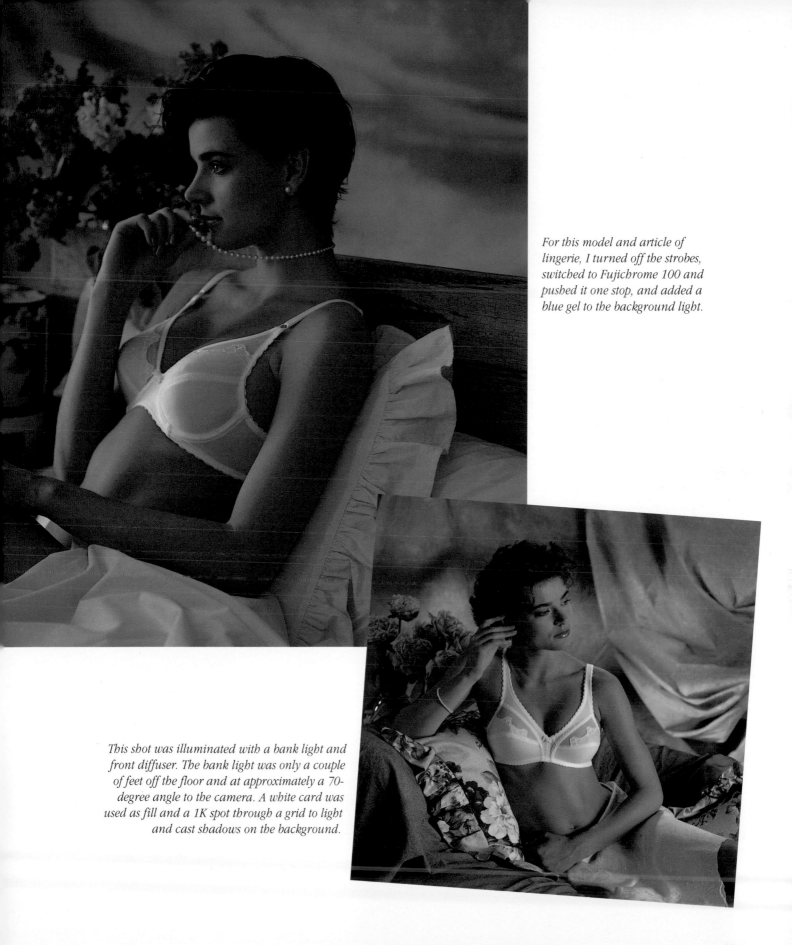

For this model and article of lingerie, I turned off the strobes, switched to Fujichrome 100 and pushed it one stop, and added a blue gel to the background light.

This shot was illuminated with a bank light and front diffuser. The bank light was only a couple of feet off the floor and at approximately a 70-degree angle to the camera. A white card was used as fill and a 1K spot through a grid to light and cast shadows on the background.

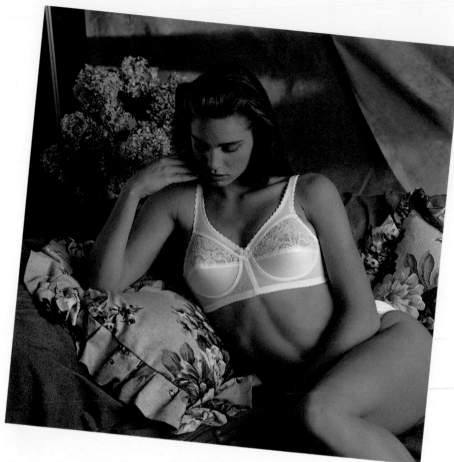

This shot shows yet another variation of the props
used for the Lovable Bras lingerie shoot. Here, Kim reclined a bit
more. A cast shadow was thrown across the backdrop, and the
cropping was turned more to the left of the set.

The third set for this assignment was very simple: a painted backdrop hung
in front of the first set (it was raised out of lighting and camera range
when not in use). This background choice expedited set changes and
enabled me to utilize the late-afternoon light. Fortunately, the available
light was the same for all three days of the shoot. But because consistency
in light quality isn't something you can count on, I had worked out a close
duplication of the late-afternoon lighting using two 2K spots in the event of
a cloudy day. Still, probably the most time-consuming part of this shoot
was the casting. This process took place on a preproduction day. The fit of
the garment is critical in terms of keeping retouching costs down. The
three Lovable Bras representatives who came from Mexico City to this
shooting were wonderful clients. They gave my staff and me a free hand
when it came time to pull the shots together and were also very clear about
their likes and dislikes—a refreshing change these days.

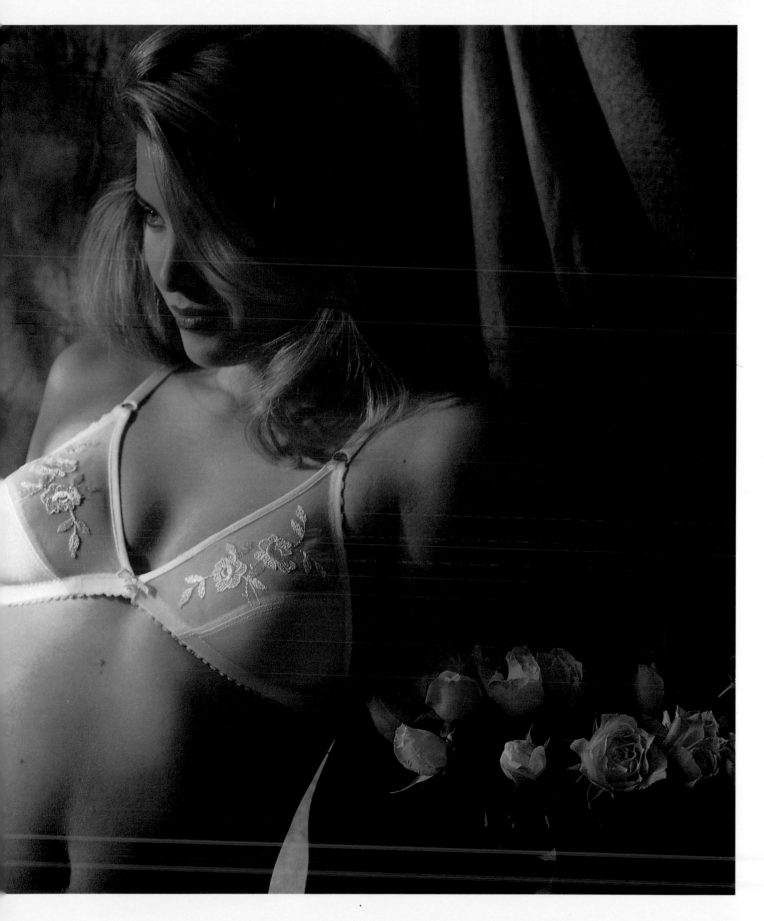

In this test shot, on Kodachrome PKM 25, the studio windows served as the background. I placed a single strobe with an umbrella next to them to make the exposure consistent as the sun popped in and out of the clouds. Then I decided to position an additional strobe approximately 10 feet behind the camera at a very low watt-second to add subtle fill.

For this tight shot, I used only available light and pushed Ektachrome 100 five stops. The model's spontaneous decision to play with the pearls added to the overall feminine quality of the photograph.

The most difficult part of lighting a lingerie shoot is carrying detail in the highlight side of a white garment without underexposing the model's skin tone. My solution is to never put the main light near the camera. This prevents flat lighting, which is the quickest way to lose detail. I almost always use some sort of sidelighting, usually adding fill from white reflector cards. (If you shoot black and white, be very careful not to burn out the highlight side of the garment. Too often, photographers think that they can adjust for poor lighting and readings in the darkroom. Get it right first on film, and the printing will reflect your precision.) When preparing the set, you also need to select a background. Basically, there are two types of backgrounds for lingerie shots: simple colored seamless papers enhanced with gels, and very feminine backgrounds. Clients typically require that the sets reflect the desired mood or the style of these very personal products.

Casting and makeup are crucial to shooting lingerie successfully. The garment must fit the model perfectly to prevent wrinkles or puckers. Retouching a fabric pattern or lace can be very expensive. Another point to keep in mind is that clients tend to shy away from models with too many freckles on the chest area. Makeup applications require a bit more thought. You don't want so much tone on the face that it seems to end around the neck, thereby making the chest and/or shoulders a different shade or color. The makeup artists I work with are aware of this and take great care when tapering the tonality from the chin down.

Playtex, a major account for which I'd done intermittent work for more than ten years, approached me about an extensive project that would continue for several years. As one of the largest manufacturers of lingerie in the world market, Playtex wanted to bring its 15 brands under one cohesive packaging design. This would save the company a considerable amount of money in design and printing costs. It wanted to apply the same logic to its packaging photography. After a meeting at Playtex's corporate headquarters, I was asked to come up with a photographic solution to the problem of having to pay models bonuses when their faces are recognizable on the package. Not showing their heads in detail would also eliminate the need for hairstyling and makeup application, thereby speeding up the shooting and enabling me to produce more shots per day. Playtex and I agreed on a price for a maximum number of shots per day, as well as a fee for test shootings during which I planned to evolve a lighting scheme to make the models anonymous.

To accomplish this, I had to make the light drop off from the top of the bra straps, so that it would produce something of a silhouette between their chin and nose. I started with strobe spotlights. But these demanded too much power to shoot at $f/16$, the aperture needed to deliver enough depth of field (in many of the shots, the model wasn't posed squarely toward the camera). The spotlights also made holding detail in the highlight side of the fabric too difficult. Furthermore, the lighting had to be easy to adjust to accommodate both the different heights of the models and the various lengths of the garments.

Playtex paid for three days of experimental lighting, so they could choose from a number of photographic ideas. We arrived at the final lighting by shooting, improvising, shooting, making small changes, and refining. Then I made diagrams and shot Polaroids of this final lighting setup, so that I could duplicate it throughout the course of the lengthy project. I even included light-to-subject distances and watt-second information because consistency was so critical. To solve the spotlight problem, I adapted some Speedotron umbrella reflectors to serve as focusing spots and used them in conjunction with a series of Matthews scrims and flags; the available strobe focusing spots weren't able to handle the power for $f/16$, the aperture needed to hold the required amount of detail.

After doing extensive tests, I chose Ektachrome EPR 64 as the film best suited to this particular job. My supplier stored a thousand rolls of the same emulsion in his freezer for me, and I kept a couple of hundred rolls in the studio. The major concern of everyone involved with the long-term project was color consistency, which we maintained by using the same strobe heads and lens, as well as a dependable lab. I created a different color background for each of the 15 product brands by using gels on seamless to produce the PMS colors that the corporate design department had chosen.

I made all of the shots with a 150mm lens on a Hasselblad ELX. Because the Hasselblad is more of a tripod camera, I use a larger ball head. Keeping it loose let me move with the models, and the motor made it easier for me to grab spontaneous shots. This was because the models had a very narrow area of movement, which prevented them from moving out of the beam of light or dropping their hands or arms in front of the garment.

This successful project kept me busy for several years as Playtex slowly changed all of its packaging for both the United States and the international market. This proved to be quite an undertaking: some of the brands had as many as 25 styles, and Playtex introduces new designs all the time.

These three images of Playtex bras were shot for use in the European market where advertising photographs have more of an editorial look. Photographers are given a lot more freedom and control abroad. For one shot, I pushed Ektachrome EPN 100 five stops; the lighting was window light (above). As the shoot progressed, I combined window light and tungsten lighting and pushed the Ektachrome only three stops (opposite page). In yet another variation, I combined available light and tungsten light once again; here, however, I pushed Ektachrome EES 800/1600 two stops (right).

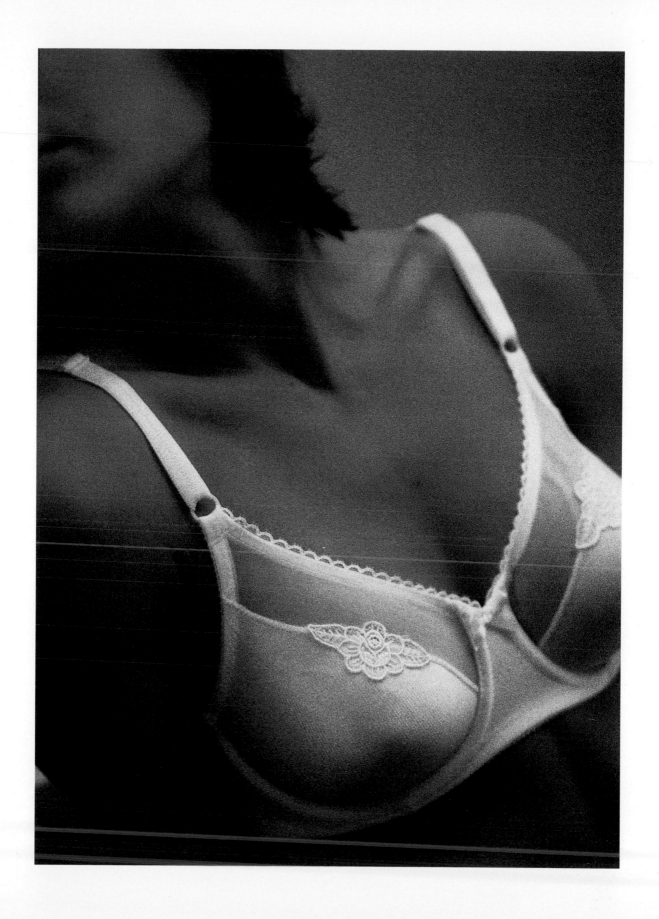

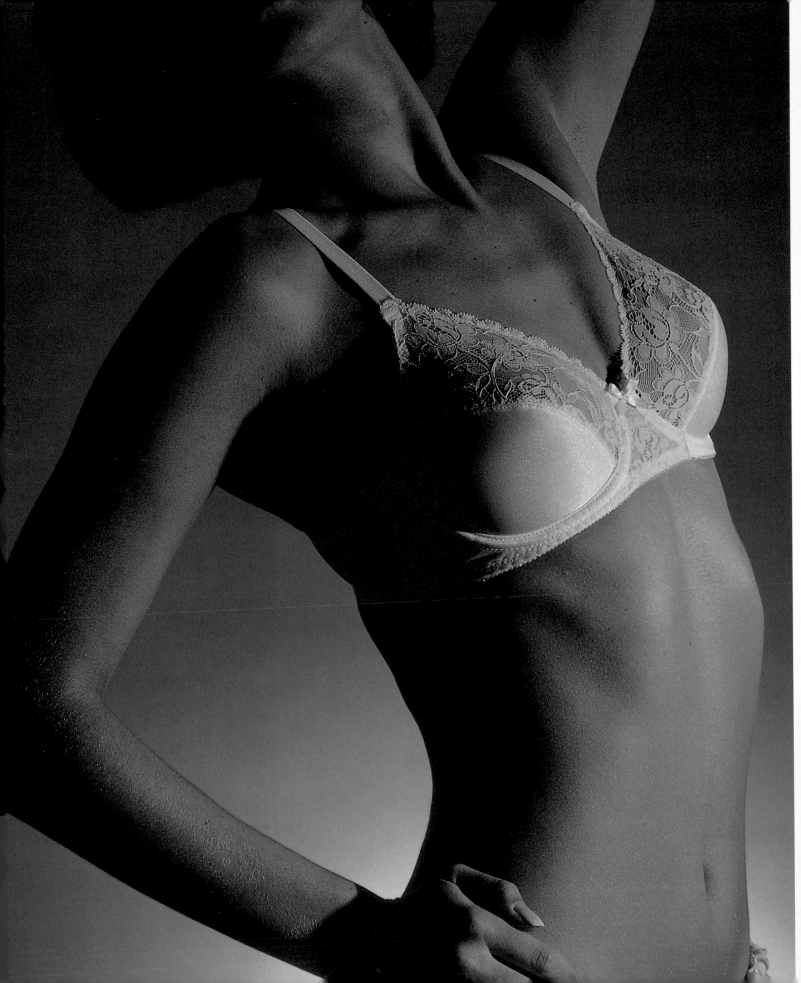

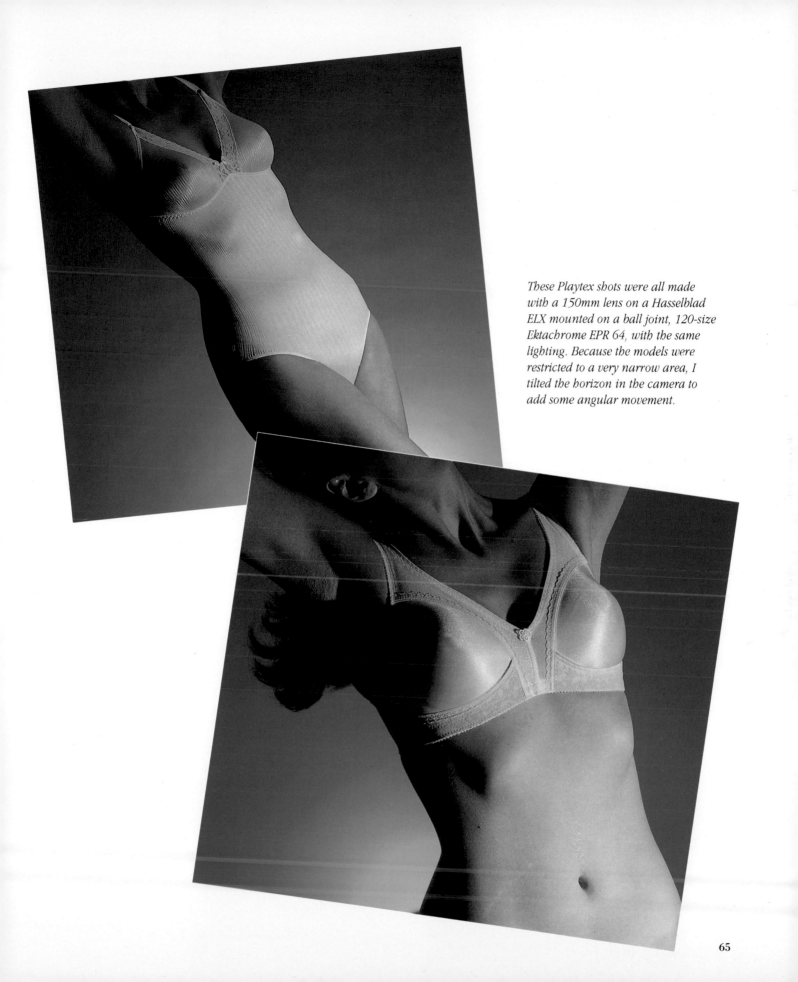

These Playtex shots were all made with a 150mm lens on a Hasselblad ELX mounted on a ball joint, 120-size Ektachrome EPR 64, with the same lighting. Because the models were restricted to a very narrow area, I tilted the horizon in the camera to add some angular movement.

Part Two
CURRENT TRENDS

The trends that evolve in the beauty-photography business seem to be based on "anything goes." You have only to look through *Elle*, *Vogue*, and *Harper's Bazaar* to get an idea of what's happening. Historically, new trends have always started between the pages of fashion magazines, and today magazines have become particularly receptive to more experimentation with color manipulations and extraordinary uses of the various film emulsions.

In the past, advertisers picked up on new trends six months to a year after they were first published. However, today new directions are picked up instantly. Actually, because of the larger advertising budgets available, many trends are seen in advertising first. This forces commercial photographers to stay abreast of the trends if they don't want to be left behind. It isn't unusual for a photographer to lose an account simply because the art director wants to try a new name or a new look. The only way to prevent this from happening is to continually shoot new material for your portfolio—not just repeating shots that you've already done, but adding new looks and techniques.

The slight danger in embracing trends too strongly is that they can disappear tomorrow, and you'll be stuck with a portfolio that won't work for you. Too many younger photographers look for a gimmick or a special-effects technique to hang a portfolio on rather than becoming proficient at their trade. Doing this preliminary work may sound boring; in fact, many very creative photographers hire assistants to handle lighting and other technical aspects of the business. But it is only a matter of time before they are in a shooting situation that requires their technical input in order for them to pull a shot out of the fire with know-how, not gimmicks. Without a solid under-standing of photographic technique, all the trends and the gimmicks in the world won't help you.

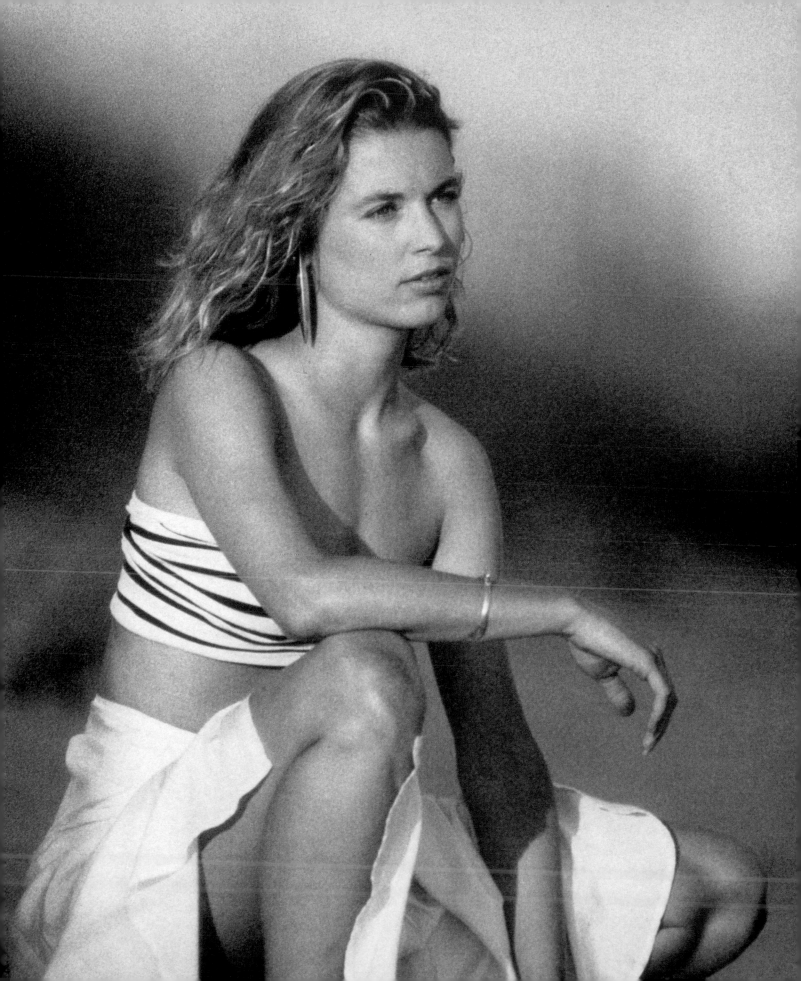

BLACK AND WHITE MAKES A COMEBACK

The last couple of years have seen a tremendous resurgence in the commercial uses of black-and-white photography. Black and white has always been the established norm in the fine-art photography business. This market has stirred a new interest in work done by some commercial photographers during the 1930s and 1940s, which, in turn, has contributed to the current boom in this medium. Photographers have embraced the lighting and the look that were created by such well-known celebrity portrait photographers as Horst P. Horst and George Hurrell. And manufacturers have expanded the possibilities with the introduction of new black-and-white films and processes. For these reasons, it is important to have black and white in your portfolio. Of course, the number of requests that you receive for black-and-white shots depends on the type of clients with whom you deal.

In my studio, I now shoot a roll or two of 35mm black-and-white Polapan for many color jobs. Upon seeing the results, a number of clients have decided to run the black and white instead of the color. Several other photographers specialize in Polaroid transfers, taking black and white another step and then sometimes back to color via hand coloring. This all fits into my own feelings toward this hobby that I call my business: I believe that there are no rules, and that your imagination and willingness to try something new establish your own parameters.

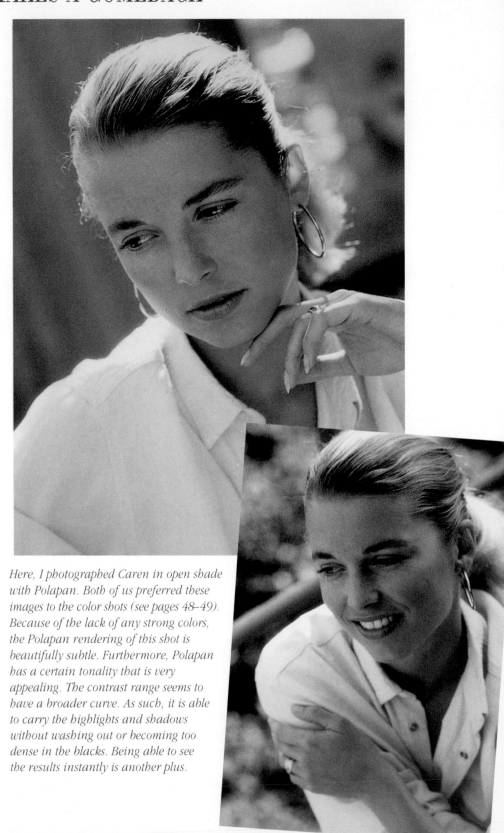

Here, I photographed Caren in open shade with Polapan. Both of us preferred these images to the color shots (see pages 48–49). Because of the lack of any strong colors, the Polapan rendering of this shot is beautifully subtle. Furthermore, Polapan has a certain tonality that is very appealing. The contrast range seems to have a broader curve. As such, it is able to carry the highlights and shadows without washing out or becoming too dense in the blacks. Being able to see the results instantly is another plus.

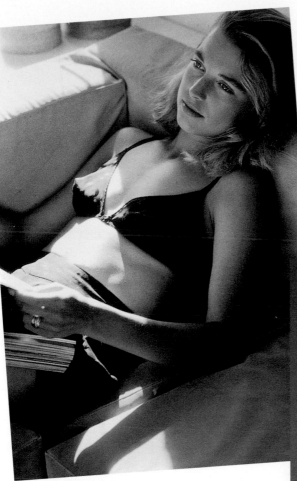

This photograph was made with available light only, which was a mixture of sun and open shade. Obviously, Polapan's range is quite broad.

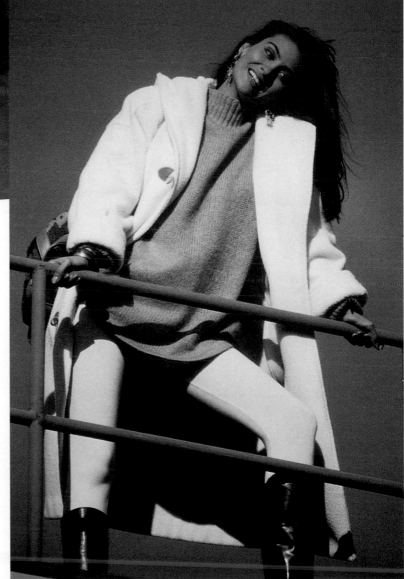

Compare this Ektachrome SO-366 dupe of a Polapan original to the Kodachrome shot (see page 55). I chose Ektachrome because of the contrast range of the original. I left the polarizing filter in place to get a darker sky, which in turn made the separation between it and the white coat more apparent. While I prefer the Kodachrome image, the Polapan is a great alternative.

BLACK AND WHITE MAKES A COMEBACK

If you decide to work with Polapan, shoot several rolls and do a couple of tests before using it on a job. You should cover yourself by shooting assignments with regular black-and-white film, too. I use Kodak's T-Max 100, 400, and 3200 for these insurance shots. Although Polapan is rated at ISO 125, my own work with the film leads me to recommend you rate it at a film speed between 80 and 100. This film definitely requires bracketing, and unlike color film, overexposed or underexposed Polapan shots sometimes look better than properly exposed photographs because of the tonal quality of the film.

When I use Polapan, I immediately make dupes of the selects after the film is mounted because it is so fragile. This is because the emulsion is so soft, which is a result of the "instant" process. It doesn't call for a hardening agent like the one used in normal fixing baths to ensure archival quality. You might even want to wear white-cotton editors' gloves when processing and handling the film. I use either Kodachrome PKM 25 or Ektachrome duping film, depending on the contrast range of the original. (All of the Polapan originals in this section were duped before printing.) While I prefer Kodachrome, it increases the contrast. So if the original is strongly lighted or inherently contrasty, you'll lose shadow and highlight detail. In these situations, I use Ektachrome.

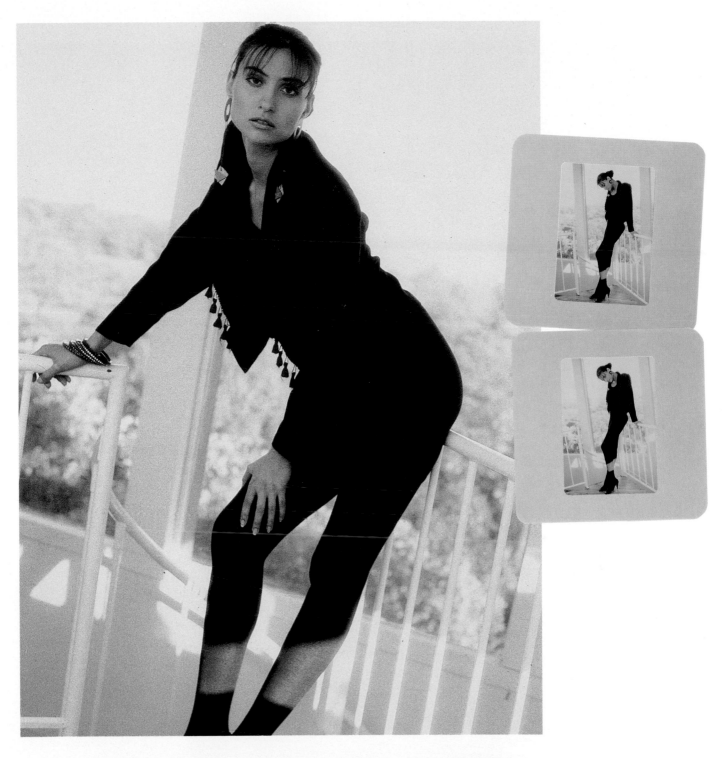

Polapan was chosen for this series of photographs because the scene was basically all black and white. To compensate for the interior of the white-on-white house and the washed-out midday sky, I combined strobe and available light to create an ideal black-and-white situation. The sky looked terrible in the color shots, but the Polapan turned this basically colorless setting into the perfect background for these garments.

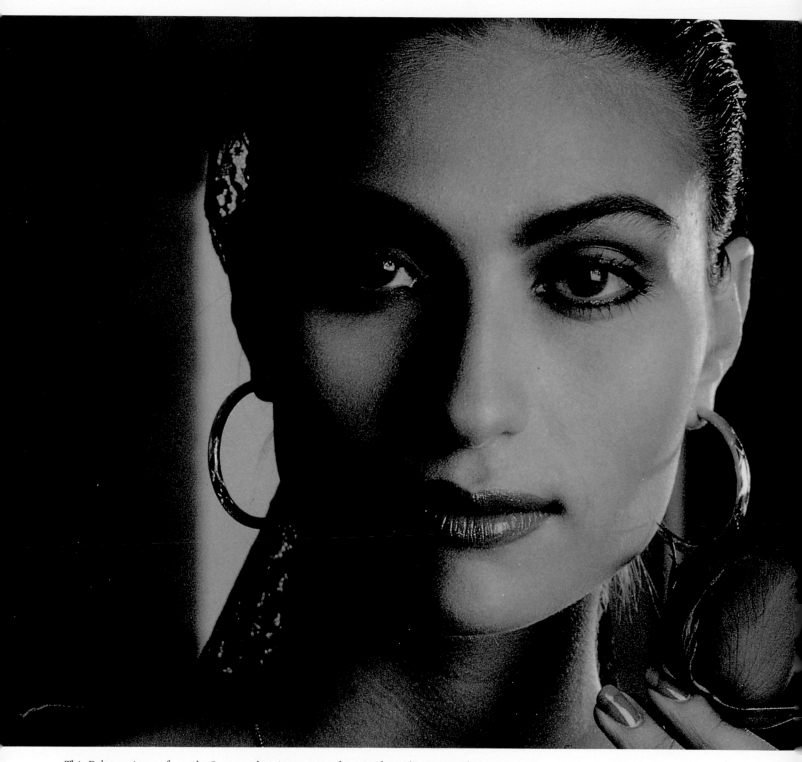

This Polapan image from the Carmen shooting was my favorite from the entire take, so I immediately made a number of dupes. This particular shot has been accepted by the Advertising Photographers of America's first awards program and will appear in its annual.

I made this photograph during the Carmen *poster assignment, too. Although the assignment was in color, I shot at least one roll of Polapan with each lighting or set change.*

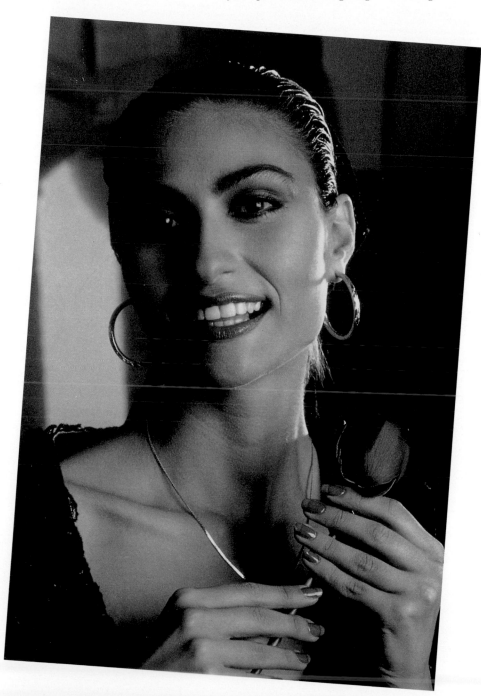

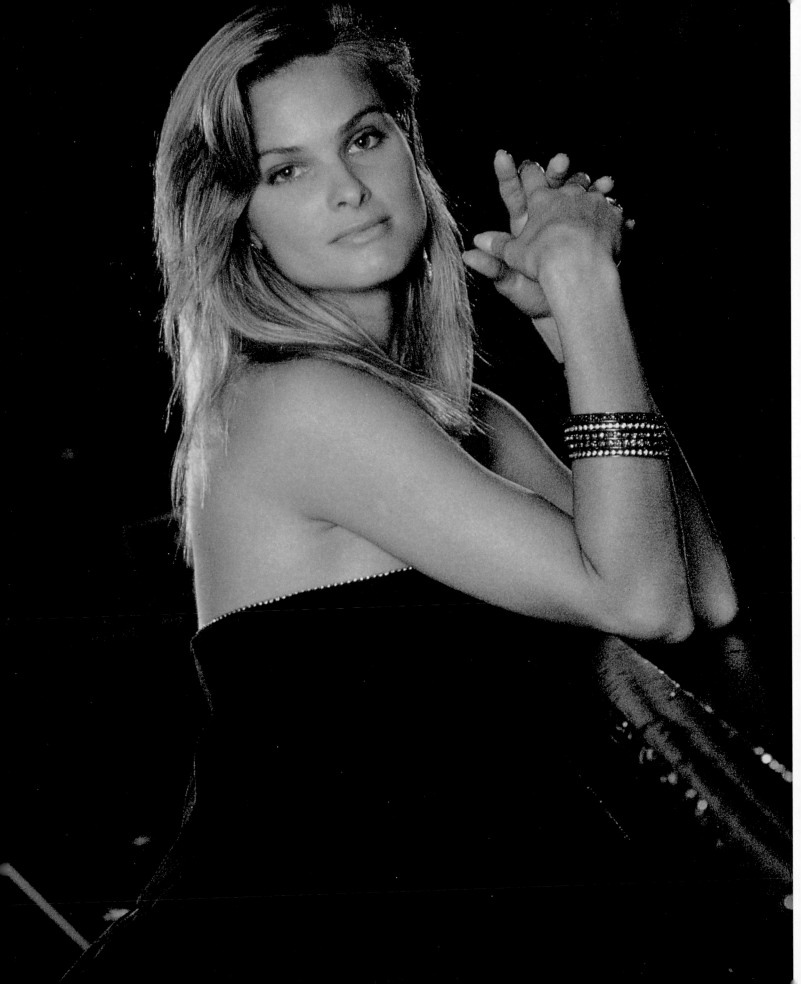

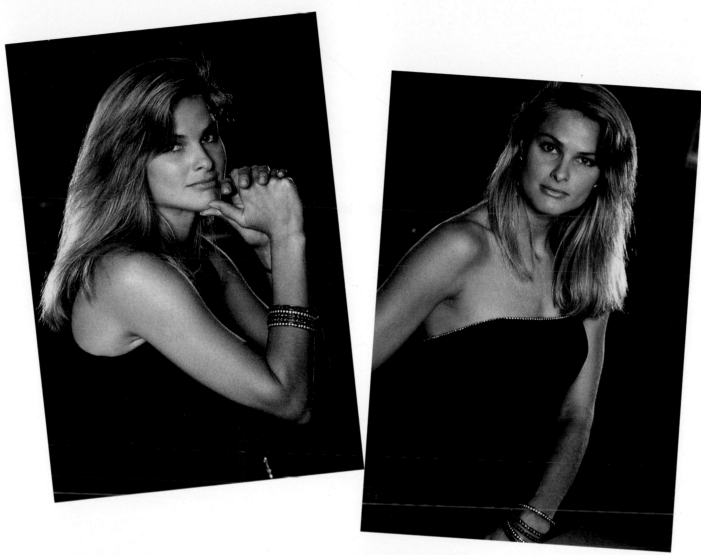

This series was made for a promotional poster for Bacardi Rum through the Saatchi & Saatchi ad agency. I was asked to duplicate a feeling already being used in Bacardi's consumer ad campaign, which was being handled by another agency. I felt this assignment was perfect for Polapan. I did, however, cover myself by shooting T-Max 100 black-and-white film, too. Shooting on location, I used three strobe heads from one 1,200 watt-second pack; two were back lights and one at camera position. I had only one pack in order to minimize depth of field. Here, the background was to drop out; only the model, Peggy Collins, was to be in sharp focus.

You have to be careful when asked to make a shot to match an existing photograph because of potential copyright infringement. The desire to be different or to have a new look frequently brings about some form of copying by those who want to jump on the bandwagon. If you're handed an existing shot instead of an original sketch or layout, you can easily place yourself in jeopardy. On all occasions, I question any layout that appears to have been swiped from a magazine, source book, or any other medium. And in fact, when I'm asked if I want to see what the last photographer did with a particular product or location, I refuse. I don't want to be either influenced or inhibited.

DRAMATIC HOLLYWOOD LIGHTING

Much of the dramatic quality of the Hollywood shots taken during the 1930s and 1940s came from the personality in front of the camera and the lighting used in films during that period. Portraits by Edward Steichen, Valentino Sarra, and C. K. Eaton, to name just a few, seem so similar that I can only assume that the limited lighting equipment available at the time is the cause. Nevertheless, the black-and-white films from that period contain incredible lighting effects. Perhaps when the film studios commissioned a publicity portrait, they wanted the lighting to be just as strong. This style of lighting became the norm for good black-and-white portraits. Recently, several high-profile photographers have rediscovered this style of portraiture and capitalized on it. Horst and Hurrell, for example, have shot Hollywood-lighting assignments for some of the "in" consumer magazines.

Hollywood lighting from that period required mostly spotlights and floods. Formulas were firmly established, such as a 2:1 or 3:1 highlight-to-shadow range. The classic portrait lighting setup was a slight sidelight forming a highlight on one side of the subject's face, as well as a triangular highlight just below the eye on the shadow side; this side was also filled in to varying degrees, depending on the amount of detail wanted there. With film stars, a hair light was almost always used to separate the individual from the background and to give the hair a bit of sparkle. Backgrounds were usually simple, with shadows created to juxtapose the highlights and shadows on the subject's face.

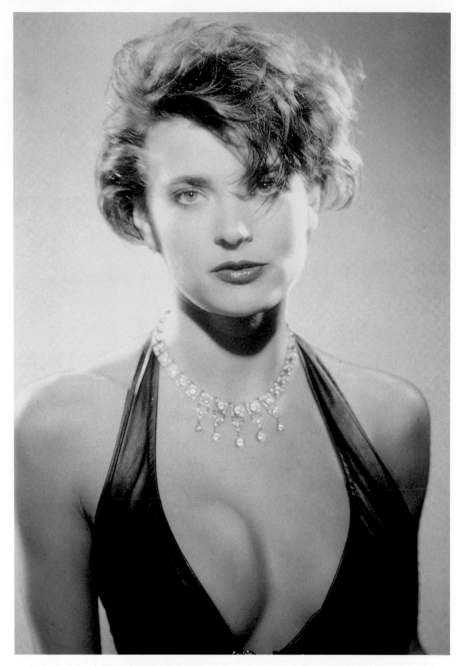

For this series with model Heidi King, I said to hair and makeup artist Ken-Ichi, "Let's have some fun. Let's turn this beautiful young lady into a Hollywood vamp." Heidi loved it because most working models seldom get a chance to really let go or to try an unusual look. To capture Heidi's "Marilyn" look on Polapan, which was duped on Ektachrome here, I used only tungsten lighting and trendy hot lights. The main light was a 2K spot with another 2K back light on the right side of the frame and a 1K on the left side. The background was illuminated with a 750-watt spotlight. The shutter speeds for this group of images ranged from 1/15 sec. to 1/30 sec.

Taking another approach, I shot T-Max 3200 and shut off the main light, keeping only the back lights for illumination. I put my Nikon F3 on automatic, which I almost never do, and just moved as Heidi moved, shooting all the time. This photograph appeals to me because it has a "grab shot" feeling.

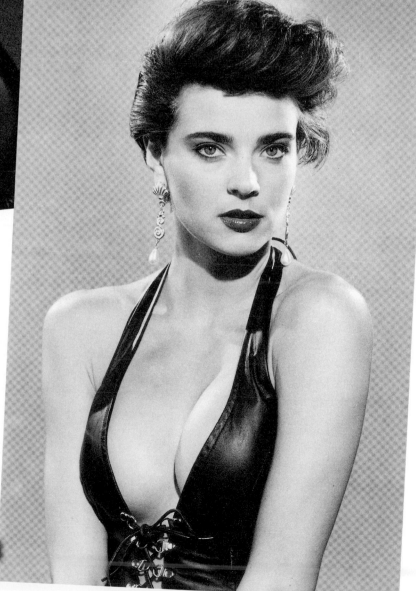

Here, Ken slightly changed Heidi's hairstyle, and I switched to T-Max 400 film. The lighting remained the same.

If these 50-year-old lighting techniques work for you, use them. Shooting color gives you even more options. Start with the same equipment used years ago; you can usually find these 500-, 750-, and 1,000-watt spotlights for cheap prices in used-camera stores in large cities. You'll also find newer designs of this type of equipment that perform the exact same function. These lights are designated 1K, 2K, and 5K; the K stands for 1,000 watts. The 2K wattage is the maximum that a standard 110-volt, 20-amp circuit can handle. Because these lights can get very hot to the touch, you should wear a pair of leather work gloves when you adjust them. I find that they work best when I mix them with strobes. When you use them uncorrected on a background, they warm up the color in relation to the shutter speed. For example, a 1/4 sec. exposure produces a yellower, or warmer, saturation than a shorter exposure of 1/30 sec. Of course, so many variables exist that you'd have to test combinations of lights in order to produce the look you want.

Today's Hollywood lighting is simply a new approach to a classic style of lighting. Its appropriateness for beauty photography is limited only by the idea you're trying to illustrate. Obviously, if the color shift is going to be too great because the spotlight is stronger than the strobe on a head shot showing a new color makeup, you wouldn't use this type of lighting. You have to be as selective with the lighting as you are with the film emulsion and the lens size. You must think of lighting as one of the tools to be used intelligently for a specific end result.

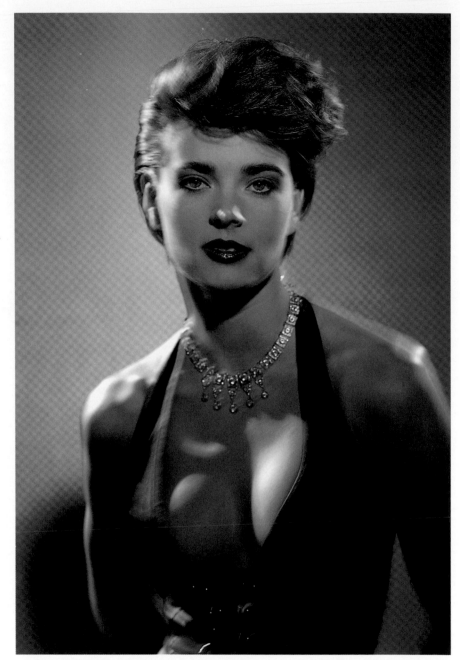

For this shot of Heidi, I chose Kodachrome PKM 25. The main light, a 2K spotlight, was replaced with a strobe grid spot; the rest of the lighting stayed the same for a mixture of tungsten lighting and strobe. Next, I changed the exposure settings to 1/4 sec. and 1/8 sec. and handheld the camera. This enabled me to pick up the ghost images created by the combination of a slow shutter speed and tungsten lighting. Although Ken had applied Heidi's makeup for black-and-white film, it still basically works in this situation. It is important to tell the makeup artist if you'll be shooting color or black and white, as well as if the lighting will be hard or soft. He or she can then use makeup to enhance the effect you're trying to capture.

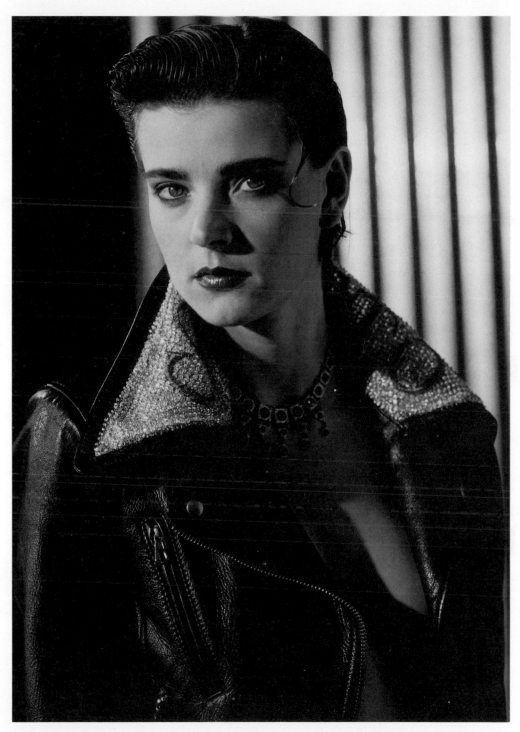

This photograph shows a complete change of looks for Heidi and a new lighting design. A 2K served as the main light, a 1K as a side light, and a white card set up as a slight fill. To complement the hard image created by the hairstyling, makeup, and leather jacket, a piece of corrugated steel from my supply of studio props was used as a background and illuminated with a 2K.

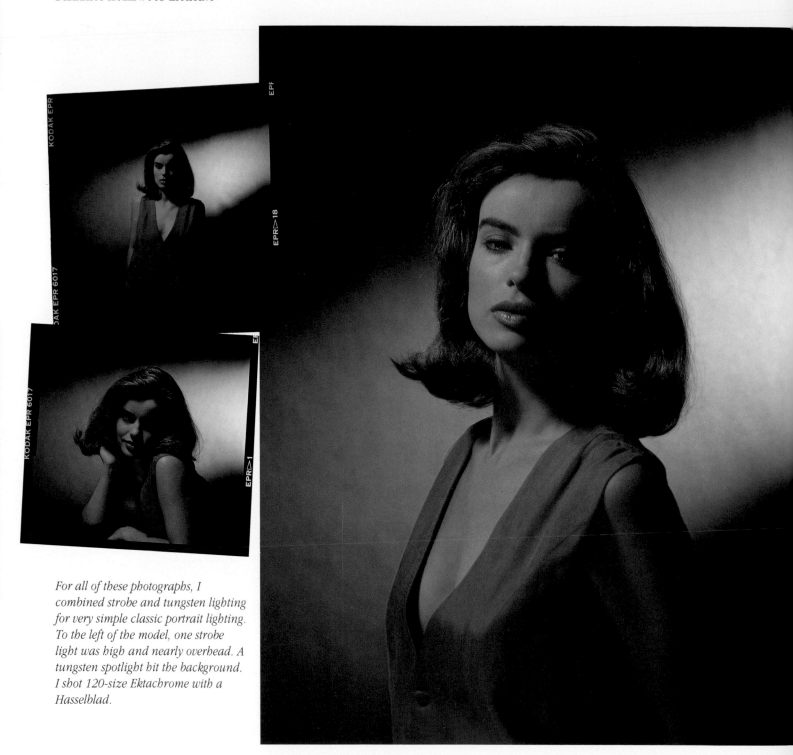

For all of these photographs, I combined strobe and tungsten lighting for very simple classic portrait lighting. To the left of the model, one strobe light was high and nearly overhead. A tungsten spotlight hit the background. I shot 120-size Ektachrome with a Hasselblad.

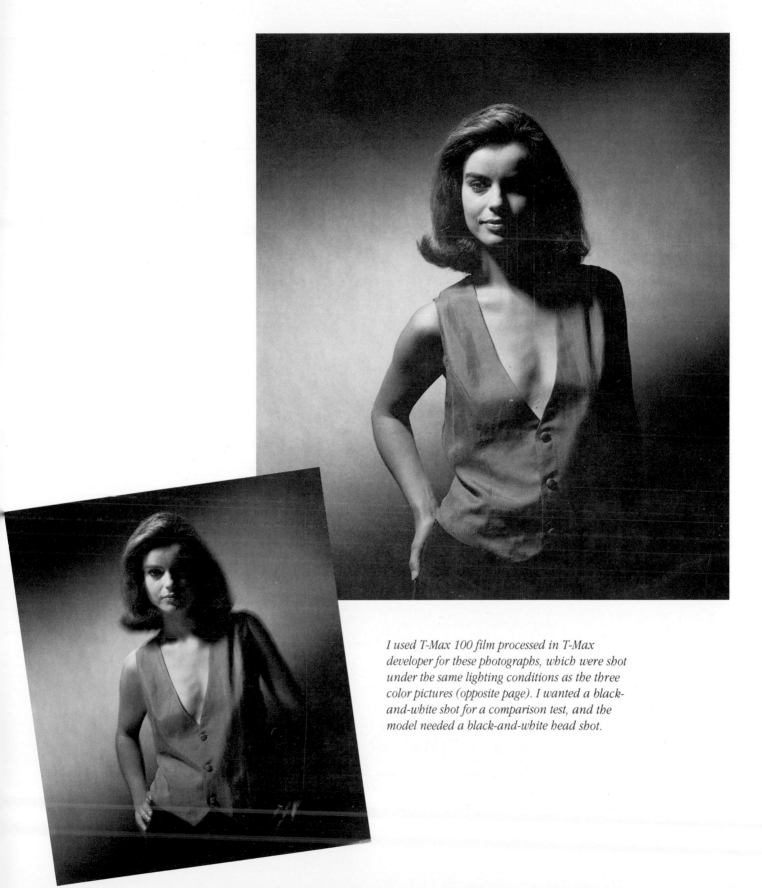

I used T-Max 100 film processed in T-Max developer for these photographs, which were shot under the same lighting conditions as the three color pictures (opposite page). I wanted a black-and-white shot for a comparison test, and the model needed a black-and-white head shot.

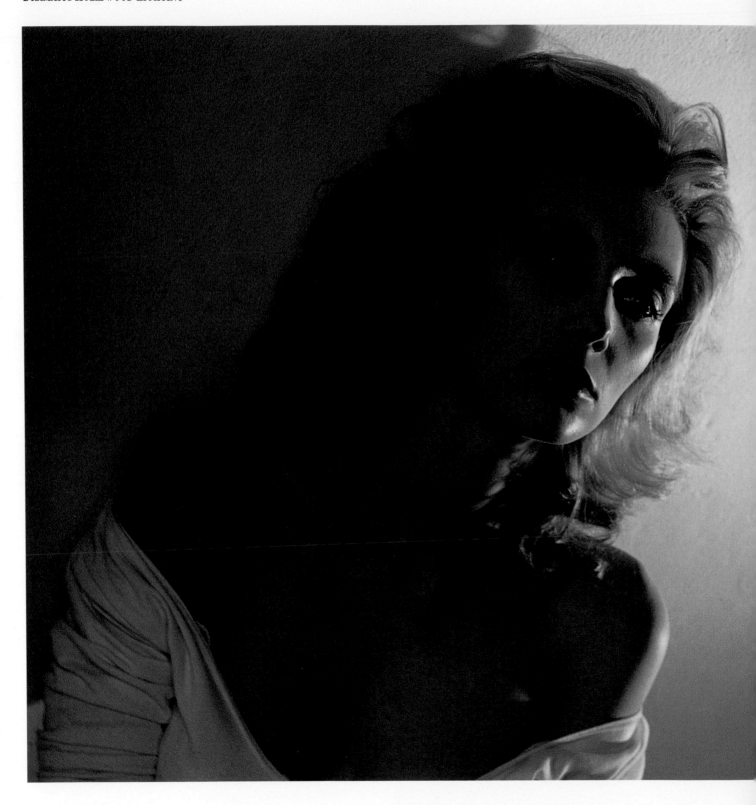

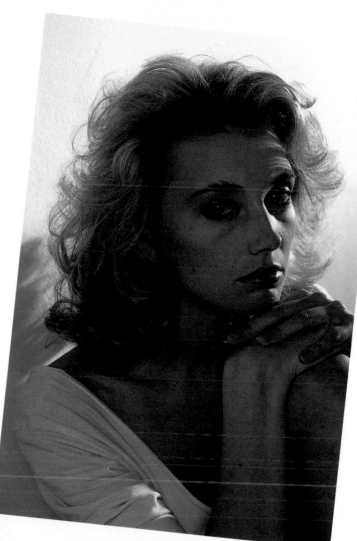

For these late-afternoon photographs of Eleana, I simply added a 2K spotlight as a back light to enhance the warm lighting, shifting it even more into deep yellows. The spotlight actually functioned as the main light, and the available light coming in through the window served as the fill light. By using Fujichrome 100 pushed two stops, I was able to handhold the camera and to shoot close to wide open. I chose the Fuji film because it tends to render warmer skin tones. The off-the-shoulder approach makes Eleana look like a 1950s starlet.

NEW IMAGES FROM POLAROID TRANSFERS

A few photographers have enjoyed commercial success with Polaroid transfers, which in turn has produced an army of copiers. While this special effect is interesting and fun to do, it is also time-consuming and expensive.

In order to successfully do a Polaroid transfer, first you need to decide on a format, such as a 4 x 5 camera, a Hasselblad with a Polaroid back, or a Polaroid camera, and to buy a lot of film. Then you have to make a normal exposure and pull the film through the rollers, allowing the film to process between just 7 and 20 seconds, based on your own tests. Next, immediately press the negative image onto the premoistened receptor. Continue applying pressure while you firmly and evenly rub the back of the negative for approximately a minute. The last step is to peel the negative very slowly from the *receptor*, Polaroid's term for the material being used to receive the transfer. (Before you try a transfer, write to Polaroid and ask for a copy of its brochure entitled, "Advanced Image Transfer, the Polaroid Guide to Instant Imaging." Reading this detailed information before you get started will save you a lot of time and money. Unfortunately, I took the long way initially and experimented, which is a euphemism for guesswork.)

For my first attempts, I used a watercolor paper with too little sizing. Finally, I consulted with Steve Spelman, a photographer/artist who works with various watercolor papers for his special graphic/photographic projects. He suggested Fabriano 300-pound hot-press paper. The receptor is crucial to successful transfers. The rest of the process was merely a matter of trial and error, beginning with my choice of subject. A nude seemed ideal to me because this is an abstract medium. Rather than have the model stand around waiting for the hour or so required for each transfer, I decided to shoot several rolls of black and white, select one shot that I liked, and print the shot on 11 x 14 paper. When shooting "live," you may get a perfect transfer of a poor image, or vice versa. Next, I set up a couple of strobes and a 4 x 5 camera for copying; I wanted to be able to work with Type 59 4 x 5 Polacolor film.

Assisted by Julie Thomas, my studio manager, I soon found that the density of the transfer was based on the length of the Polaroid's development time. The longer I let the Polaroid develop before separating it and pressing the negative onto the receptor, the lighter the end result was. During the first several tests, I gave the negative 6 or 7 seconds of processing before starting the transfer procedure. This proved to be too short because the image came up too dark. When I extended the processing time to between 12 and 15 seconds, the negative retained less density and the transfer was lighter.

At this point, I prepared the watercolor paper by misting the side that would be used for the transfer. I continued misting the paper until it was soaked, shook off the excess droplets, and then blotted the paper with a paper towel until it had a wet (not blotted) look. I made the exposure, gave it the processing time I wanted, carefully pressed the two together, and then with the transfer lying on a hard surface slowly but firmly rubbed the back of the negative with a small ball of paper toweling. You must make sure that the two don't shift under the pressing and transfer; this will produce a blurred image.

I tried a variety of transfer times, even as long as an hour! The best results had a processing time of about 15 seconds and a transfer time of 90 seconds. I worked in an open studio under normal light conditions. The color range of the positives that were left from the transfer was as interesting as the transfer itself. I hadn't fully processed any of the positives, which was something I'd never done before. Finally, I handcolored the transfers with soft-colored pencils and lightly rubbed in the color with my bare fingers. I wanted to see what else I could do with them. It is rather difficult to get any saturation from transfers, and the base color of the receptor paper has a great deal to do with the overall color.

I can see using a Polaroid transfer for a very special shoot, such as a story illustration or even a beauty illustration. This technique has been used quite nicely for a couple of fashion features and portraits, too. In terms of its commercial use, you would need to have the type of client that sells a mood or a specific lifestyle and is willing to use a semi-abstract image. A Polaroid transfer is another technique that you can explore to see if you are really interested in it. Remember, though, it calls for a lot of patience and time, and you can't control the outcome.

When Eleana came to the studio for a go-see, the light was perfect. First I shot a series of Polaroid transfers, lighting her with a simple strobe spot because very soft lighting is too subtle for transfers (below). At the end of the shooting session, I felt that I should also cover it with film in case the transfers didn't work; I would then have some transparencies to use in a Polaroid printmaker so that I could continue working on the transfers (right). Next, I changed the lighting, using only a 2K spotlight and the window light as fill. I wanted a more dramatic feeling. By walking around Eleana and shooting from various angles, I was able to capture a series of striking images. The lighting produced different effects from opposite angles. I pushed Fujichrome 100 two stops to handhold the camera. The edge light with the off-the-shoulder effect gives the picture a very 1950s-movie look.

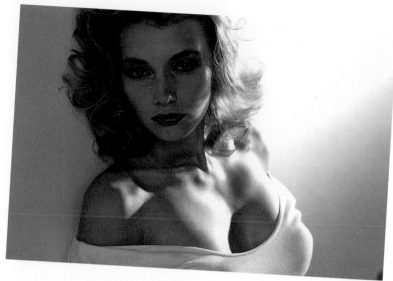

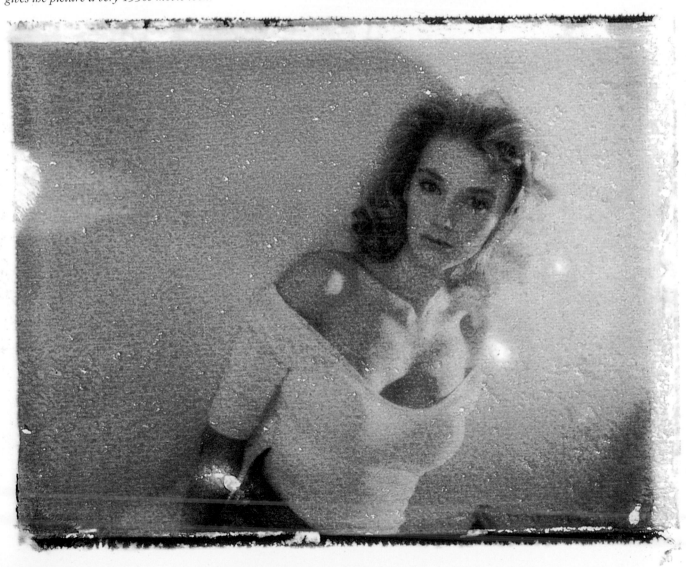

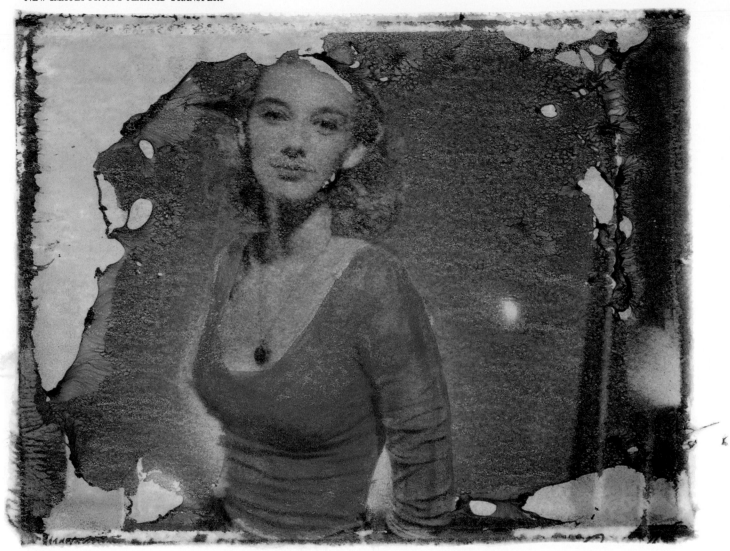

For this shooting I first started with a Polaroid back on a Hasselblad, but the extra emulsion from the unused part of the film caused a lot of problems when I peeled the film from the transfer receptor.

At this point, I decided that we should give transfers another try using a model and the smaller film size. To speed up the process a little, I set up a mini-assembly line with Julie, my studio manager. She performed the actual transfer process while I kept shooting. We used two types of watercolor paper but still found that Fabriano produced the best results.

Switching to a Polaroid 185 camera, which I ordinarily use for casting and lighting checks, I exposed the entire sheet of film. For this series of transfers, I used Type 669 Polacolor packs. (Unfortunately, the 185 camera has been out of production for about ten years. It is a real gem, with a full complement of f-stops and speeds.)

After spending the better part of two days experimenting with transfers, I concluded that the two most crucial factors in a successful transfer are the receptor, and the pressure and rubbing at the very beginning of the transfer process. (Of course, the wetness of the paper is also very important but you have to base that on the type of paper you're using, the length of the transfer, and negative density. If you don't apply just the right amount of pressure and rubbing, small bits of emulsion either will pull away or won't be transferred.) As you can see, the Polaroid transfer process is a medium of individual expression. But for professional purposes, it is at best an imprecise technique that you have very little control over. It requires lots of time and patience—and lots and lots of Polaroid film! I handcolored the "Eleana's Dreams" series of transfers with watercolor pencils and then softened the pencil lines with a small watercolor brush and water.

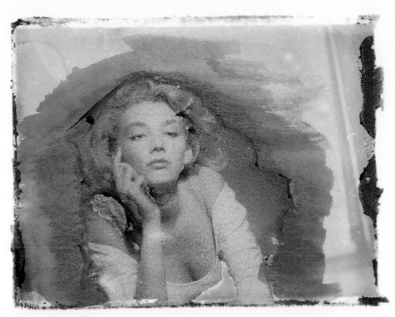

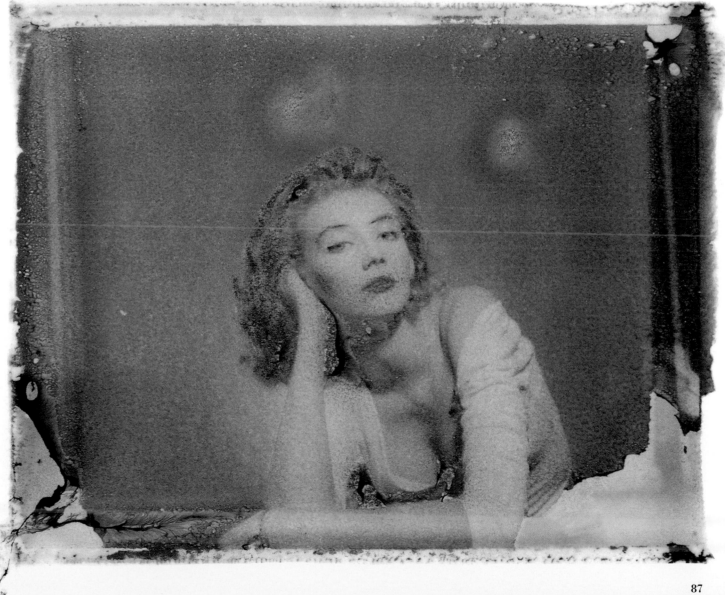

THE ELECTRONIC PHOTOGRAPH

Brian Edwards, my assistant, made final adjustments on the Sony ProMavica MVC-5000 by examining the image on the monitor.

Here, Brian loaded the 2-inch disc that can retain 25 images at high resolution and 50 images at low resolution.

For me, still-video photography is like watching instant replays during a football game, except that I am in my studio doing a beauty shot. It is absolutely wonderful to be able to shoot 25 frames at high resolution on a disc, drop the disc into a playback machine, and look at the images before shooting another disc. (You can shoot 50 frames at low resolution, but the lines from the video signal are too prominent for a hard copy, or print.) And if you don't like the shots on the first disc, you can shoot it again. For a simple beauty shoot with a bright background, I decided to work with a Sony ProMavica MVC-5000 still-video camera. This state-of-the-art piece of equipment uses a 2-inch still-video floppy disc to capture the images. This isn't a digital system; it is an analogue system that converts images into electronic signals to record high-quality still videos.

This Sony still-video camera is about half again as large as a Nikon F3 or F4. Although it is very well balanced for handholding, for all practical purposes you need to use a tripod with it. The zoom lens I chose for this project was about 1½ times the length of a Nikon 180mm lens, but its focal length was the equivalent of approximately a 35mm to 300mm range with a macro adjustment included. The camera does, however, have a couple of nagging design flaws. For example, the reset button that returns the camera to the automatic mode is directly below the PC sync-cord plug. As a result, you can easily bump it while plugging in the sync cord. Also, the diopter dial should have either click stops or a lock because it is too loose and

seems to roll out during use. Without realizing what was happening at first, I found focusing difficult. With the exception of these two minor flaws, the Sony ProMavica is a very well-thought-out piece of equipment.

Wanting a bright background color for this shoot to simplify any comparisons to film shot under the same conditions, I decided on blue. This would enable me to easily detect differences in skin tones, the whiteness of the teeth, and the background itself. The most pressing problem was figuring out an effective film speed for the disc. Consultants at Ken Hansen Lighting recommended that I start with ISO 50, a rating that called for an exposure of $f/5.6$, 1/60 sec. on my Minolta flash meter. But the first test frame taken at that exposure was several stops overexposed. So I erased the image and tried again—a great convenience! After several tests, for which I worked backward by changing the ISO setting on the meter to suit the image, I finally arrived at an effective film speed of ISO 100 at half-sensitivity. I also found the images much brighter and more saturated with the camera in the manual mode and strobes; I adjusted the white balance after checking the shots on the monitor.

Because it is impractical to set up all the equipment required to pull prints from the discs, I used only the camera, a monitor, and a playback unit that could be hooked up to the monitor or the Nikon printer. One of the best features of this system is being able to shoot a few frames, play them back on the monitor, and then make lighting and slight makeup changes before you start the final

shoot. Another option is to use a Hasselblad and a ProMavica in conjunction, mounting the Hasselblad above the ProMavica on a tripod via a special adapter. You then plug them into a special synchronization unit that fires the ProMavica when you hit the Hasselblad shutter. After you shoot a standard roll of 120-size film in the Hasselblad, you remove the disc from the Mavica and run through the shots to see exactly what you've just captured on film. Sony refers to this as *electronic proofing*.

Editing was a delight. I was able to sit with the model, the hair-and-makeup artist, and other people who were involved and go through the entire take. This was quite unusual. And although it was fun to get everyone's opinion immediately after the shoot, it isn't something I want to do on a regular basis after 25 years of doing my own editing!

Getting prints for reproduction followed. Scott and Bernard had made all the arrangements for me up to the point of "Now what do I do with the discs?" They were very good at helping me obtain a couple of prints. The best ones resulted from scanning the images into a Mac and having the image information digitized and then printed on the Nikon printer. I was then able to use this information to make either transparencies or separations.

Despite the ease of electronic images, don't rush out and sell your current equipment. I think that you'll be using it for some time yet! The Sony ProMavica costs approximately $10,000, not including the other equipment that goes with it. The electronic-proofing process intrigues me, so when the price is reduced by about half, I'll be interested in getting one for studio productions.

Chris, the makeup artist for this shoot, did some last-minute touchups on the model's makeup before the shooting session began.

Here, model Angela Lamb waited on the set with the fan and reflector in place. I used standard film lighting. The white balance was set at 5800 degrees.

For this shooting session with the Sony ProMavica MVC-5000, I used three strobe umbrella heads.

As we played back the first disc during the session, my staff and I discussed makeup and attitude changes.

This print was made on the Sony printer directly from the disc (above). After I fiddled with the controls and ran through a number of prints, this was the closest I could come to the Kodachrome (opposite page). If I'd gone any larger than this, the video scan lines would've started to make the print fall apart. (I used the same lighting for both series, changing only the camera.) This isn't to show how much better film is than electronic images; it simply shows you where the electronic image is at this point in time. The improvements will most likely come in quantum leaps, just like the ones the computer industry has seen during the last ten years. What does this mean about the future of photography? I think we can look forward to a very exciting decade!

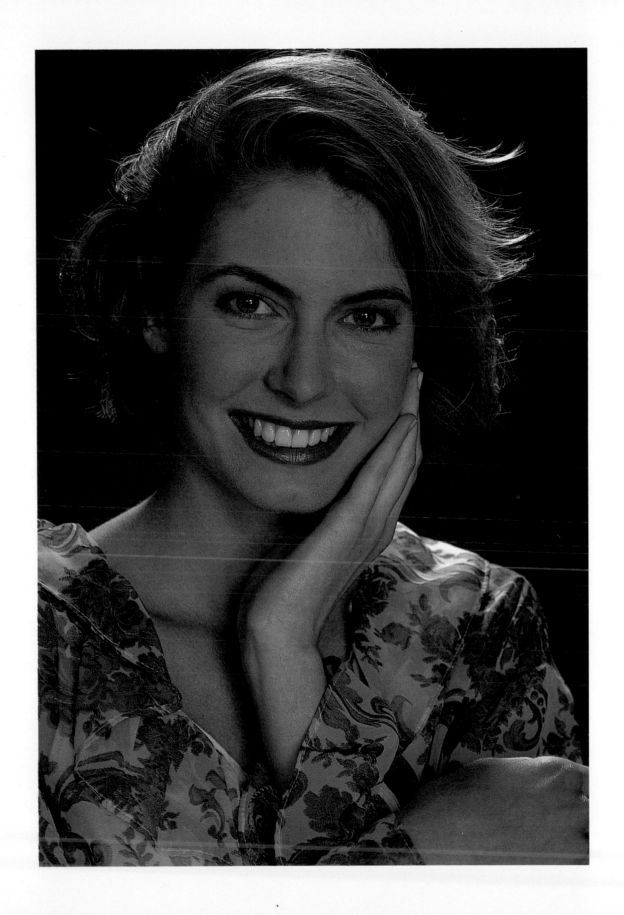

This color print was made on a Sony printer directly from the disc that contains the shots I did using only the modeling lights, no strobes. I set the camera on automatic for this exposure and for color balance.

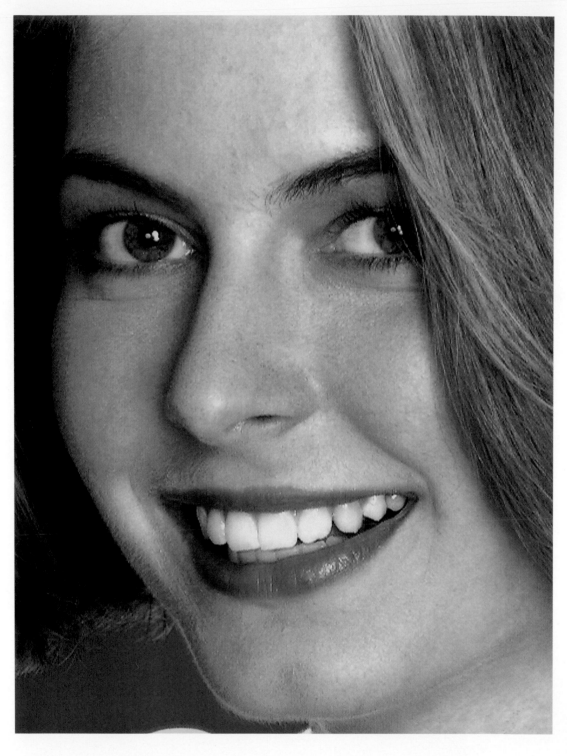

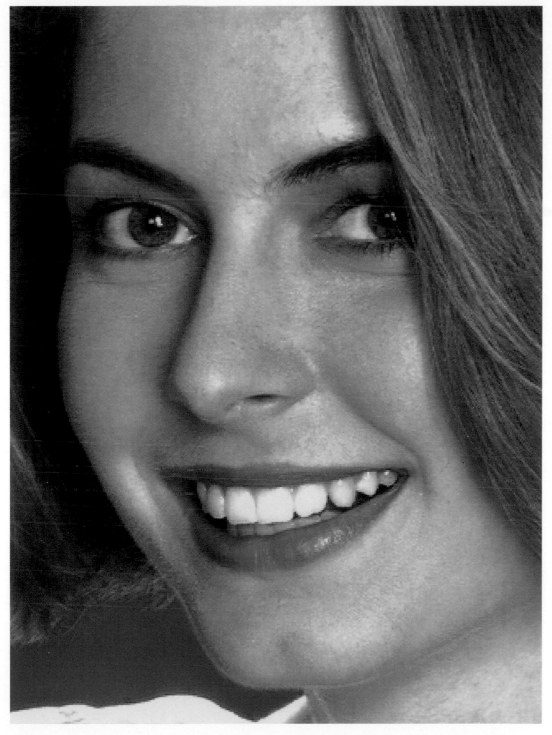

This print is the result of using the Nikon printer and scanner in conjunction with a Macintosh computer. The Sony print is definitely sharper and more suitable for reproduction (opposite page). The color here is much too warm, and edges, such as the teeth, seem to break up strangely. Also notice the breakup of the soft-focus shoulder area. But considering that no film was used, the results are quite remarkable. (Both shots here are shown larger than they were actually printed.)

Part Three
SHOOTING LIFESTYLE FOR STOCK

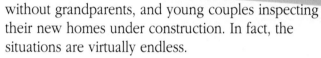

Stock agencies didn't create the stock-photography business, although some might claim that they did; they've just shaken a sleeping giant. This has become a very sophisticated business, supporting many photographers throughout the world. The better stock agencies, such as The Stock Market, spend a lot of time and money marketing the work of their photographers. And with the advent of stock catalogs and express-mail companies, art directors in Omaha, Tokyo, and Hamburg can select a shot that works for their layout and have the image the next day.

A question I hear all the time is whether or not stock has ruined the assignment business. If anything, I think that stock photography has created new markets (although it has probably cut into the travel-photography field). But the best material isn't shot blindly or on a whim. Stock photography is driven by market needs; stock doesn't set any trends or styles of shooting. The most successful stock photographers in all agencies have recognized the value of producing work to meet market demands.

"Lifestyle photography" has become one of the new catchy terms for the 1990s in ad agencies, magazines, and other media. So many ideas for stock photographs are generated by a collective image created by television shows, films, and research that reflects market demands. For example, since the beginning of the television program "thirtysomething," photographers have received numerous requests for this look. And before that, a Benson and Hedges cigarette campaign influenced the current look of advertising and editorial photographs. I've been shooting lifestyle for years, doing beauty shots in the studio and photographing couples on location. Lifestyle also includes family members engaged in different activities, with and without grandparents, and young couples inspecting their new homes under construction. In fact, the situations are virtually endless.

Stock agencies picked up on this lifestyle idea several years ago, and many photographers started funding their own production shootings geared toward this market. When shoots are properly researched, scripted, styled, and cast, using wardrobe and hairstyles that won't look dated within a year, good photographers can make their money back in a relatively short time; in addition, the shoot has the potential to earn money for about five years. All this takes is a little ingenuity and energy. In order to do your own production shoot, you have to be motivated and self-reliant. You must also take charge of your destiny; you can't spend your entire career waiting for someone to call you. Finally, you have to function as your own creative director, art director, producer, and critic. Most productive, successful stock photographers conduct these shoots the same way they do when they're working a major campaign for any number of clients. Their resulting sales reflect this professionalism.

Although stock shoots require a great deal of effort on your part, you aren't working in isolation. The stock-photography business has become very sophisticated, with stock agents doing their own

During a conversation, one of my researchers mentioned that we could always use new photographs of upscale young women. I called my daughter Shannon, who models, and she asked one of her close friends, stylist Laurie Durning, to put together a number of shots using a Chanel wardrobe. We worked around New York's upper Fifth Avenue. Shannon and Laurie got portfolio shots, and I got my fashionable, young East Side woman shots. This image was made with Kodachrome and a 180mm lens on a Nikon.

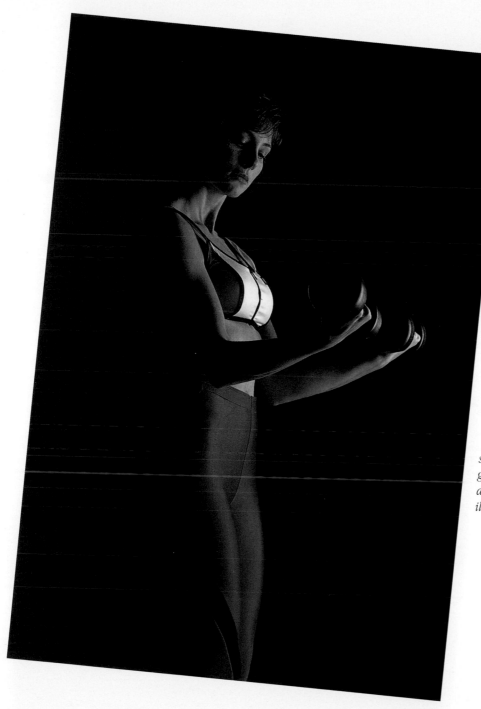

This session started as a test shooting for a possible promotional poster for a product made by a sponsor of the Olympics. The art director wanted a simple posterized effect to try to sell to the client. This wasn't a "finished" shooting, just a "comp" for layouts. The model was backlighted on both sides with several strobes stacked using standard 11-inch reflectors covered with a diffusion material. The blue seamless was enhanced with blue gels. In the end, however, the client decided to go with the artist's illustrations.

research into market needs and passing this information on to their photographers. Despite all of this available help, within each agency only a handful of successful producers of consistently salable material take advantage of it. It amazes me that with all of the magazines and printed matter we're bombarded with through the mail, as well as all of the beautiful commercials on television, how little attention many photographers pay to market needs. I don't know how many times friends who are art directors have said to me, "I just saw John Doe's portfolio yesterday. It's a very nice book, but I don't think he ever looked into what I do or what our magazine needs are. There wasn't anything in the portfolio that was remotely close to what we are about." So utilize the important information that stock agencies can provide.

I also recommend paying your models up front and getting releases—for everything. If you photograph a house or an antique car, get a property release. If you photograph someone's dog, get a

release. Be specific when wording the release. This will prevent you from receiving an angry telephone call two years later from an individual in a shot of yours on a billboard, claiming that he or she didn't know the image would be used this way and asking for more money. If you're not working in a relatively large city, supplying your subjects with photographs in exchange for a release is often sufficient. But be sure to state this in the release. The days of walking through the park and grabbing a nice shot of a family playing together don't exist anymore. If you see a potential shot, explain what you're doing to the subject, ask permission, and get a release. If you can't, file the idea away in your photographic memory and re-create it some other time.

Finally, before you go to an agency, do a little research first to make sure that it handles the type of material you like to produce. And, remember, lifestyle photography is a major industry. Shots made over the shoulder, so to speak, just can't stand up to the fierce competition that exists in the stock business today.

After I finished a shoot that required a set with a window and clouds, my crew and I removed the window, repainted the wall, and stylist Nicole Zizelis selected some shocking wardrobe colors. I then asked model Lisa Stimmer to do a promotion shot for me. Photographed on Kodachrome, Lisa was illuminated with one large umbrella directly over the camera on a boom. The Broderson backdrop was lighted separately with four strobe heads through umbrellas goboed to prevent light from spilling back onto Lisa.

CLASSIC BATHING SUITS

Thanks to *Sports Illustrated*, bathing-suit photography has been raised from the pinup calendar to an art form that is in great demand by many national magazines. However, except for the fashion magazines, most of them don't do nearly as nice a job as *Sports Illustrated* because they don't have the funds required to take top models to some of the most exotic beaches in the world. And, needless to say, a beautiful model in a gorgeous bathing suit looks even better when she's photographed on a deserted beach in Seychelles than at Coney Island. But with a little ingenuity and a bunch of long lenses, you can usually transform any beach—within reason, of course—into an acceptable background.

The single most important factor in photographing bathing suits is the casting. The client, the art director and/or editor, and the photographer usually collaborate on the choice of models. If you're starting with a model who has a specific problem, you'll have to spend most of your time working around this part of the body instead of having the freedom to shoot from any angle. However, don't let anyone talk you into using any type of body makeup other than one of the newer toner/moisturizer products—unless you want to see someone photograph orange. The few times that I was forced into using body makeup were disasters. Not only did the makeup look too orange, it streaked and ran if any water got on the model and stained the garment. It also took about three hours to apply.

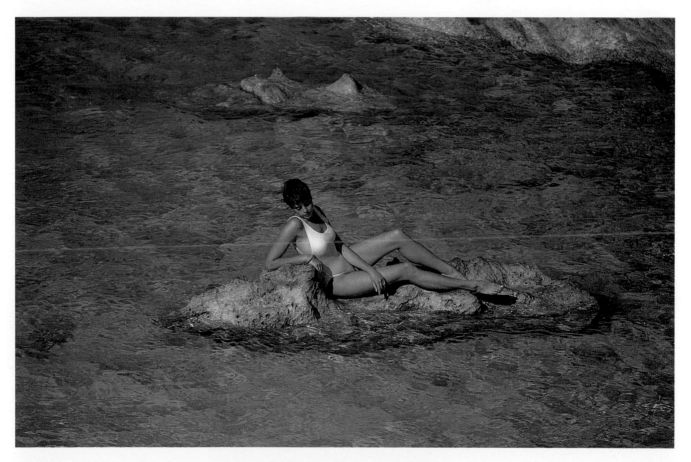

This photograph was made on location in a grotto in Bermuda. My crew and I were working from a cliff above the grotto, which made communication difficult because of the wind and waves. A yellow suit was selected for the color contrast; a red one was rejected as too loud. Shooting on Kodachrome PKM 25, I chose a 180mm lens and added a polarizer.

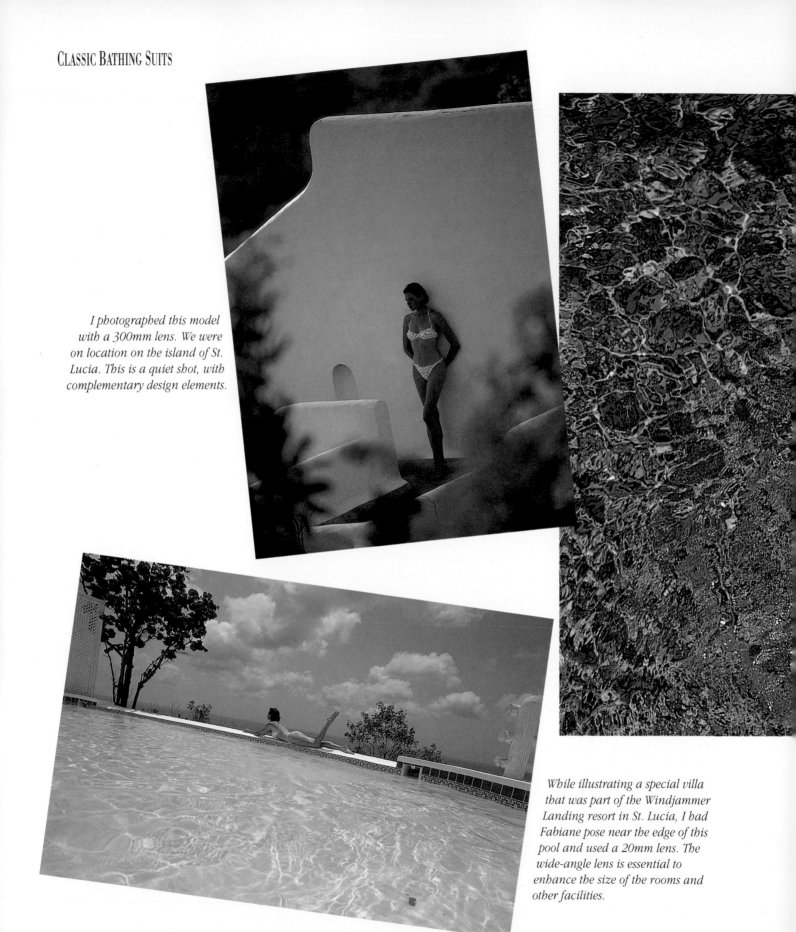

I photographed this model
with a 300mm lens. We were
on location on the island of St.
Lucia. This is a quiet shot, with
complementary design elements.

While illustrating a special villa
that was part of the Windjammer
Landing resort in St. Lucia, I had
Fabiane pose near the edge of this
pool and used a 20mm lens. The
wide-angle lens is essential to
enhance the size of the rooms and
other facilities.

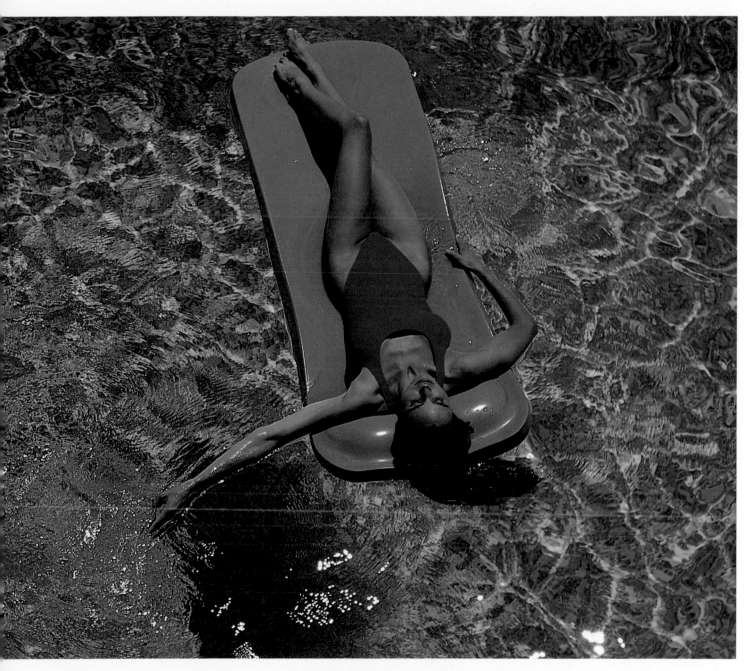

I made this photograph while standing on a 10-foot ladder and used a 50mm lens and Fuji Velvia. I purposely shot at midday in order to work with the sun overhead. Although the model's hand seems relaxed, she was actually making ripples with it on the water's surface. This added more interest to the interplay of highlights.

You also need a little understanding of anatomy. Does the waist look smaller when the model is standing or lying down? Is there a good hip line? Do the arm muscles or shoulder blades look awkward? A little knowledge in this area goes a long way toward transforming a mediocre shot into a beautiful image.

The fit and color of the bathing suit are also very important. A suit that looks great on one model may not look good on the next. One-piece suits that are cut high on the hip provide the most flattering look overall, although suits with string bottoms are very popular. Depending on their skin tone, some models look better in a specific color range. Most of the time, models have pretty strong opinions about which suits look good on them. Nevertheless, fittings are a must for any swimwear shoot.

When planning this type of shoot, you also have to consider the lighting. Early-morning light and late-afternoon light are the most flattering for these shooting situations. But you must pay attention when you shoot at both times during the course of a day. Too often, photographers forget to remove the warming filter that they use in the morning; as a result, their subjects turn very orangey-red in the late-afternoon light. The use of a polarizing filter enhances saturation, but it can also create problems. With some films, in a fully polarized shot a highlight can disappear or almost look solarized. When using a polarizer, move it a quarter or a half turn to carry part of the highlight. This provides more depth or modeling.

For this sunset shot in the Bahamas, I decided to use a white umbrella as a soft fill light to prevent losing the color reflecting on the water and still carry slight detail in the face. I also used an 85mm Nikkor lens here.

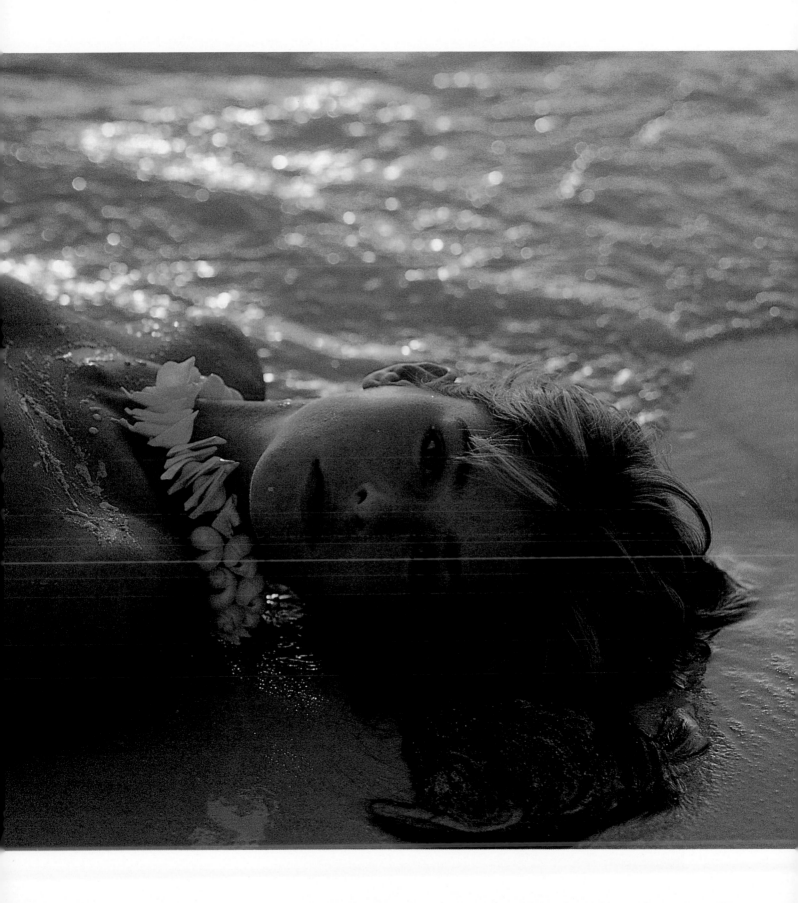

I shot this series at my Connecticut studio. First, a 9 x 10-foot frame was covered with plain muslin and painted bright yellow. The frame was then hung from two Matthews "high rollers" at the sunny end of the pool. The camera was at the opposite end. I knew that by my placing the background in the full sun, any color used on the muslin would be picked up in the pool reflections. Carol, my producer, stylist, and manager of stock productions (who also happens to be my wife), held the frame to counteract small gusts of wind. I used a 180mm lens, a polarizing filter, and Fuji Velvia because it enhances blues and greens, resulting in more saturated images.

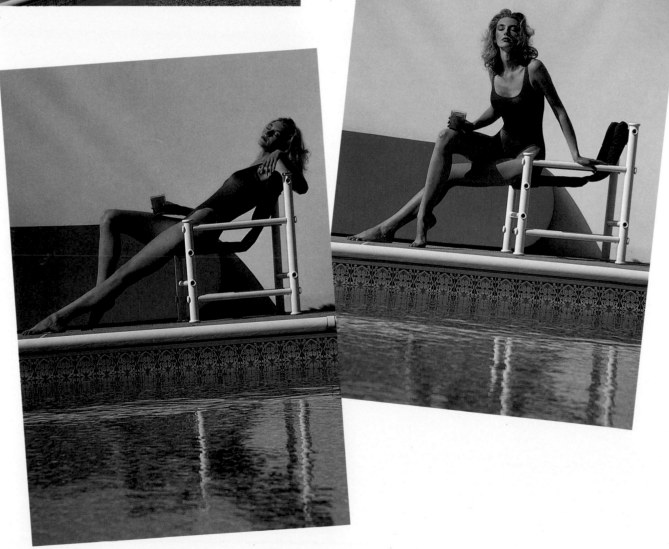

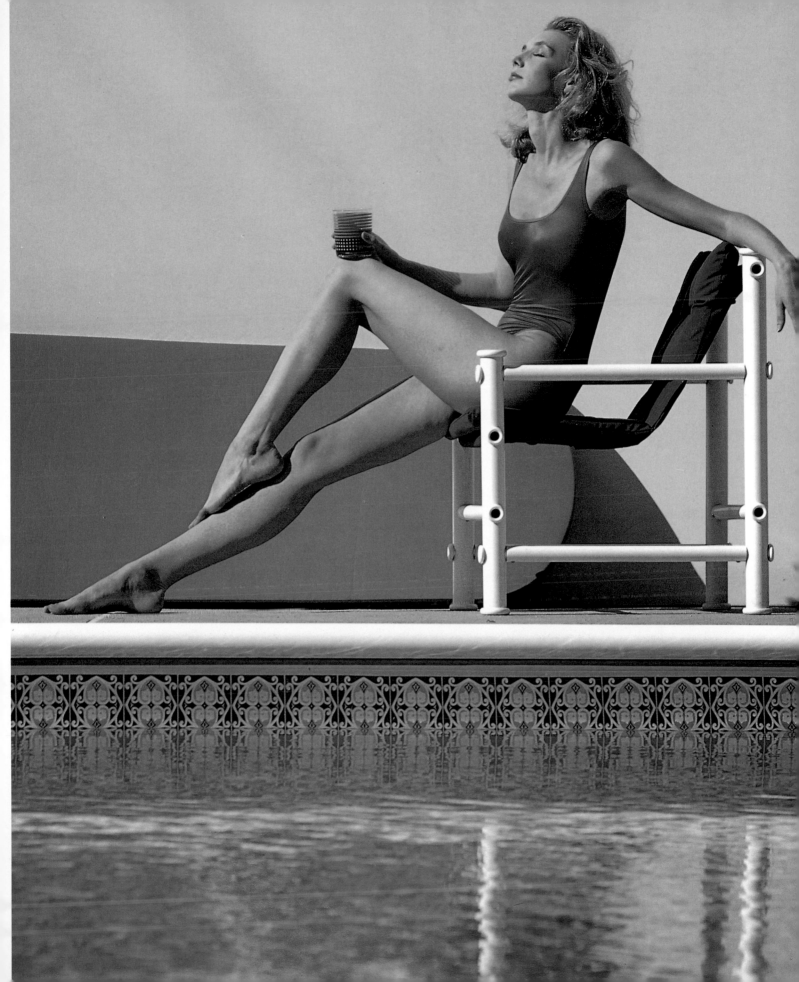

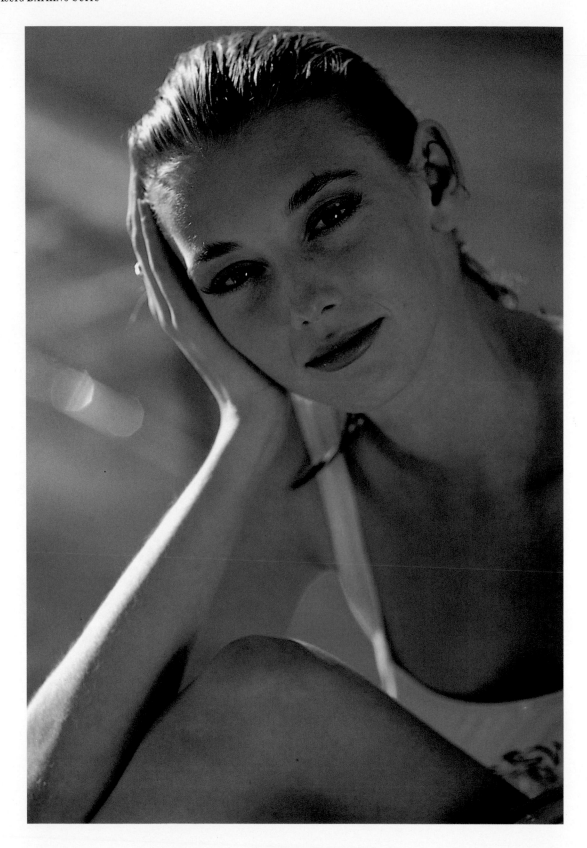

Photographs of models wearing bathing suits call for careful lens and film selection. Long lenses can do a lot for swimsuit shootings. I usually use lenses that range from 180mm to 500mm, but my 300mm *f*/2.8 lens is the workhorse. Not only does it enable me to control the backgrounds to the point of completely dropping them out, but it produces a flattening perspective that flatters the body. Film selection, of course, is very personal.

Fuji Velvia is quite popular because it offers enhanced saturation. You might want to do a series of tests with this film. This is especially true late in the day when it renders skin tone a bit reddish. I still prefer using Kodachrome KPA 25 to achieve a neutral yet fully saturated look.

And, of course, locations for bathing-suit shoots are obvious. The prettier the color of the water and the sand, as well as the number of

swooping palm trees, the better the shoot will be. Don't overlook this fact or skimp in this area. Despite all the tricks in your camera bag, you still can't do the old "sow's ear, silk purse" routine if everything isn't working for you. For example, I can't make a painted backdrop and a ton of sand in the studio look like St. Bart's. Find the right location before you start shooting, or at least make the most of the circumstances.

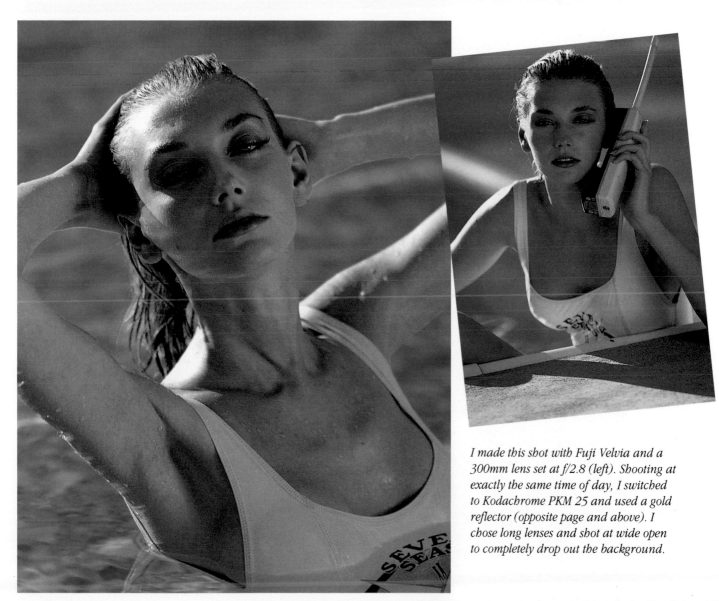

I made this shot with Fuji Velvia and a 300mm lens set at f/2.8 (left). Shooting at exactly the same time of day, I switched to Kodachrome PKM 25 and used a gold reflector (opposite page and above). I chose long lenses and shot at wide open to completely drop out the background.

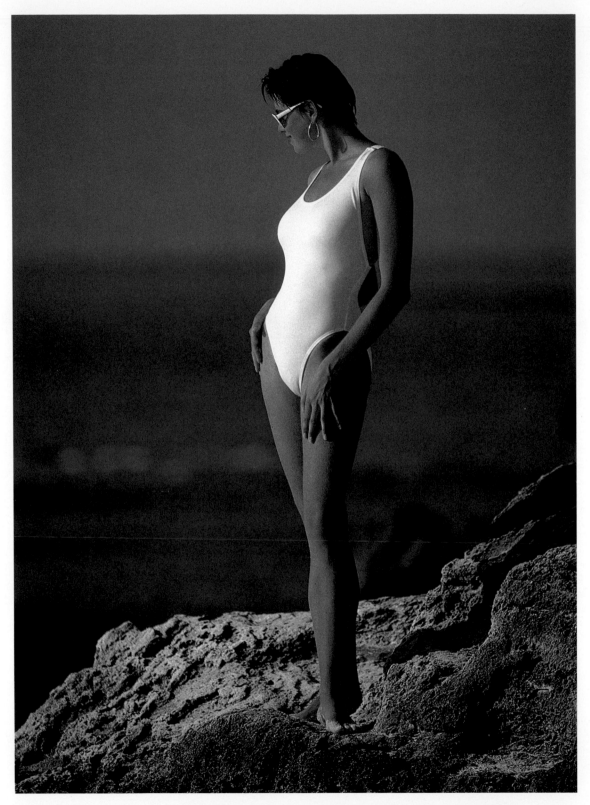

This photograph was made on location in Bermuda. Here, I combined a 300mm lens and a polarizer.

MOVE OVER, SPORTS ILLUSTRATED

After seeing the *Sports Illustrated* 25th Anniversary video of its swimsuit shooting, I decided that it was time for a satire. When a publication starts to take itself that seriously about as simple a subject as bathing suits, you have to say, "Wait a minute. This isn't going to change the world. These are lovely young women in a shake-and-jiggle video designed to make Time, Inc. a lot of money." When you can't laugh at yourself, it is time that someone else does. One morning over coffee, Nicole Zizelis, my studio manager, came up with the idea of creating bathing suits from stuff she would buy on New York City's Canal Street. This is where you go when you're looking for a special widget to hold a set together, a used fan motor, or strange Lucite shapes. You can buy almost anything on Canal Street.

While Nicci put together six bathing suits, I tried to sell the idea as a videotape or calendar. At one point, we had a backer. But the backer then decided that I should feature a couple of top models. This ruined the idea of a satire for me, so we produced six shots and used them as mailers.

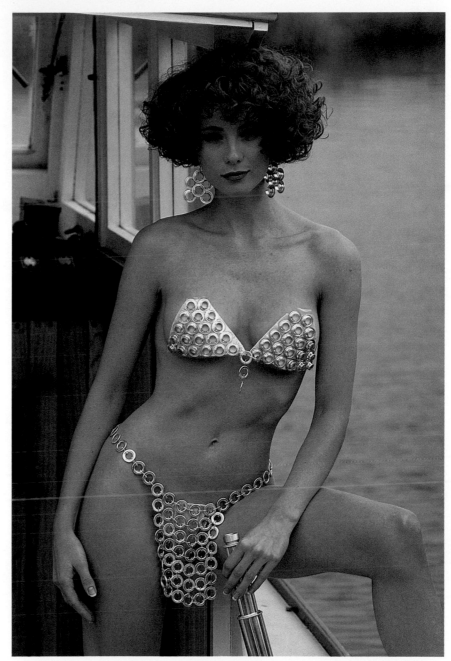

For this satire of the Sports Illustrated *bathing-suit issue, which was fun to shoot, I used Kodachrome exclusively. Lisa is actually a brain surgeon, but in her spare time she models and restores old boats. Her bathing suit was made from grommets, and the bottom was held together with metal clips. The top was a special problem. My staff and I finally settled on an adhesive material that is designed to be worn under strapless garments to hold breasts in place. A portable Norman 200 watt-second strobe was used as a fill light.*

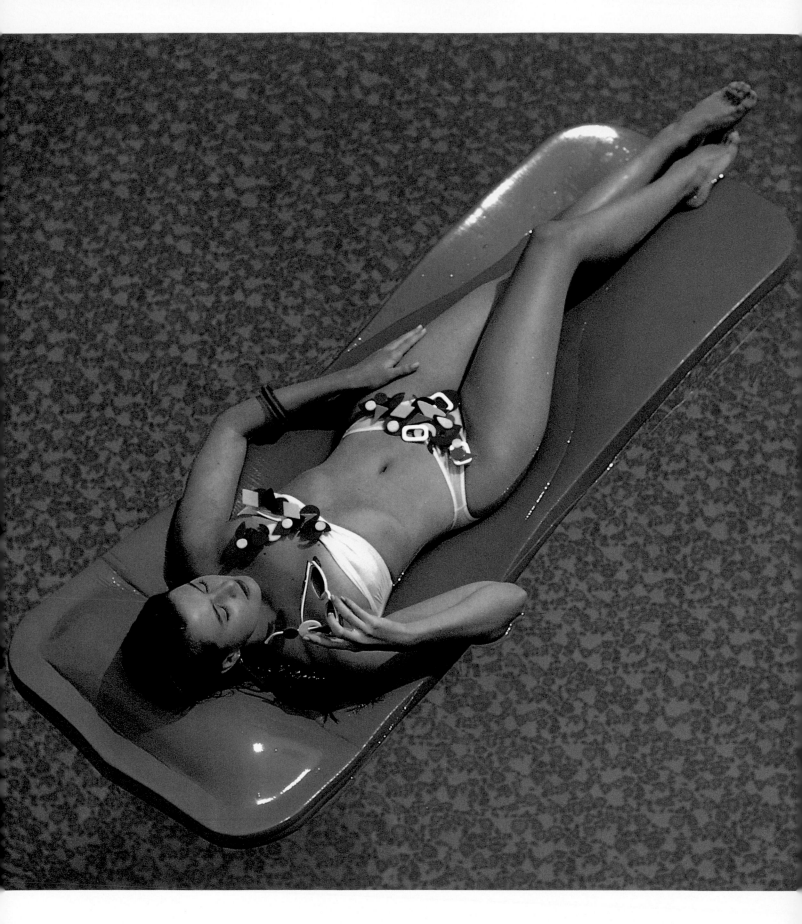

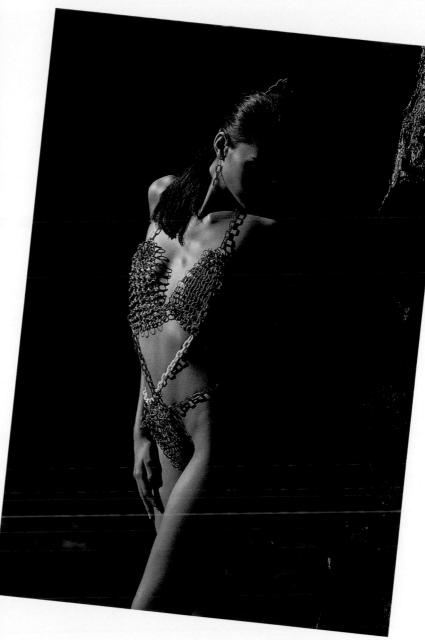

This colorful suit (above) made of chains painted various colors, isn't recommended for sunbathing, sitting, or swimming! Here, I used backlighting without any fill. In another shot (left), a plastic suit on a plastic float in a plastic pool was combined with a real live Kim! To get this picture, I shot from a precarious perch atop a 10-foot ladder.

Here, farmhand Kelly wore a bathing suit made from recycled paper. After a ten-minute swim this type of suit disintegrates, so you don't have to deal with the problem of emerging from the water in a cold, clammy suit. A gold reflector was used for fill.

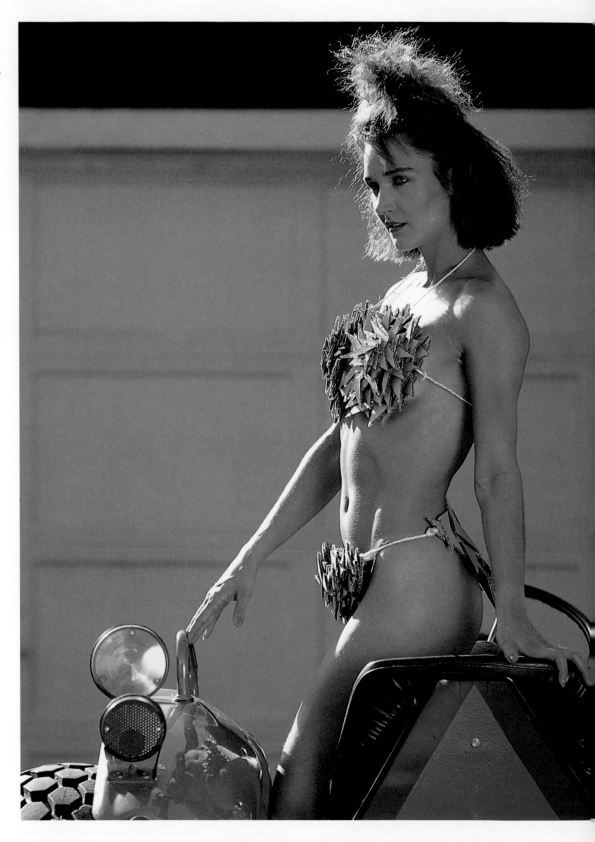

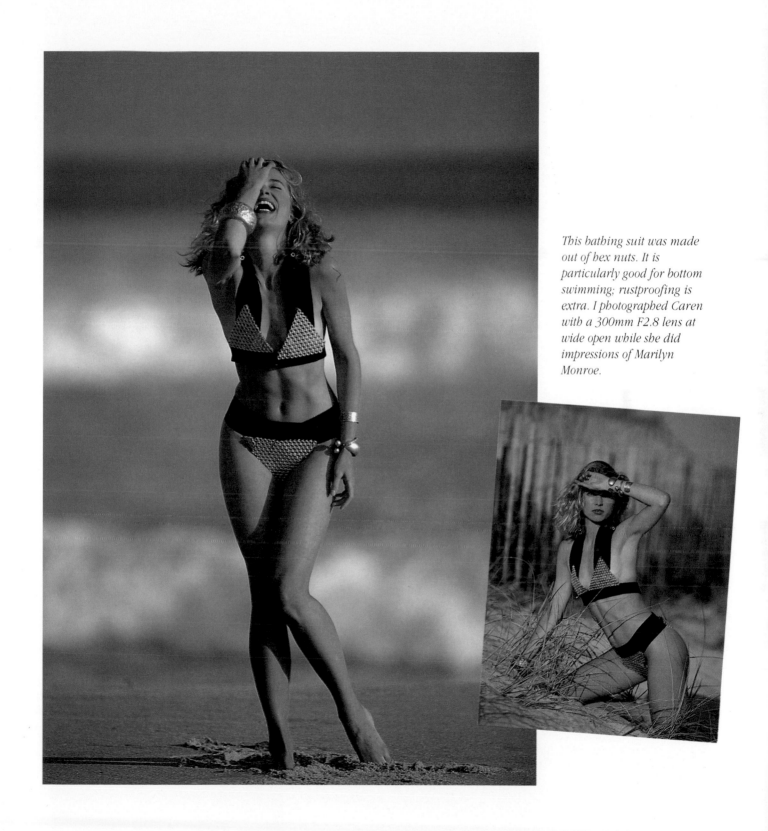

This bathing suit was made out of hex nuts. It is particularly good for bottom swimming; rustproofing is extra. I photographed Caren with a 300mm F2.8 lens at wide open while she did impressions of Marilyn Monroe.

TIME FOR COUPLES

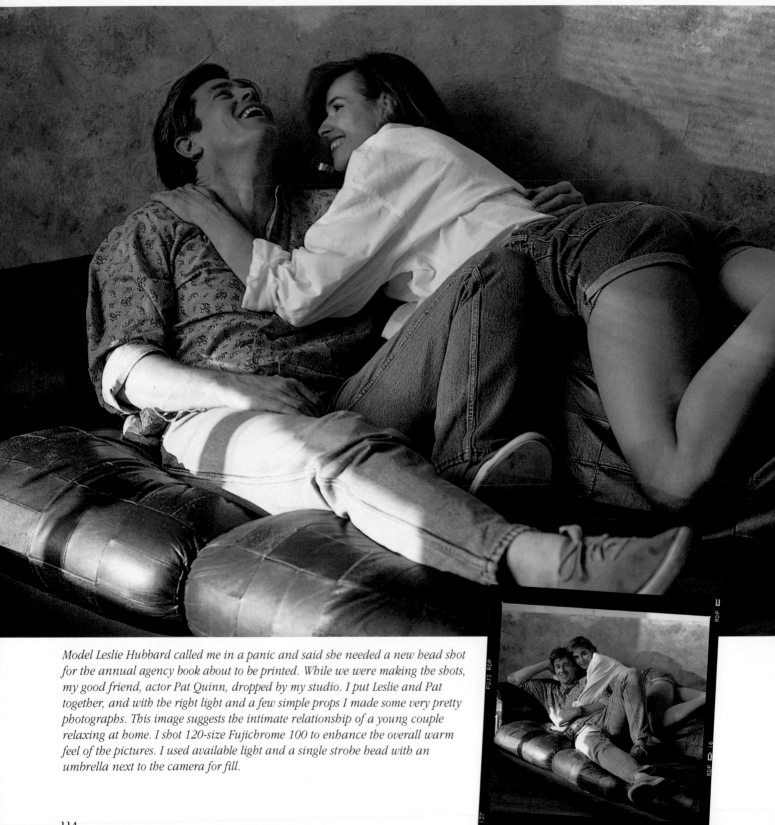

Model Leslie Hubbard called me in a panic and said she needed a new head shot for the annual agency book about to be printed. While we were making the shots, my good friend, actor Pat Quinn, dropped by my studio. I put Leslie and Pat together, and with the right light and a few simple props I made some very pretty photographs. This image suggests the intimate relationship of a young couple relaxing at home. I shot 120-size Fujichrome 100 to enhance the overall warm feel of the pictures. I used available light and a single strobe head with an umbrella next to the camera for fill.

Because of all of its possible variations, lifestyle photography is a little more complicated than some other types of photography, such as fashion. Suppose, for example, that a shot calls for you to photograph two couples using a 300mm lens. Here, you have to be concerned about depth of field. When couples are involved in some sort of activity, your entire approach to a shoot changes, and more care is required all the way around. You have more wardrobe to check, more hair to watch, and more expressions to pay attention to.

In fact, each addition to a shot, whether it is a person or an object, gives you one more element to consider. If you don't direct or place it properly, it can ruin the scene. There is nothing worse than noticing that one of the key players has lipstick on a tooth or a hair out of place in an otherwise perfect shot. To minimize the chance of this happening, I always try to have everyone—the stylist, the hair and makeup artists, and the client—look through the lens when time permits. One of them might spot something that can make the difference between a great shot and a mediocre one.

Here the late-afternoon sun poured through the studio windows that face west, so I asked the models to turn their backs to the light. A white card provided fill.

While scouting Treasure Cay in the Bahamas, my
crew and I found this beautiful deserted beach with a
sandbar. This meant that I would be able to shoot in
both directions as the sun moved across the sky. As
you can see in these two photographs, we brought a
number of wardrobe and prop changes with us. The
shots were made on Kodachrome PKM 25 with a
180mm lens (above) and a standard lens (right).

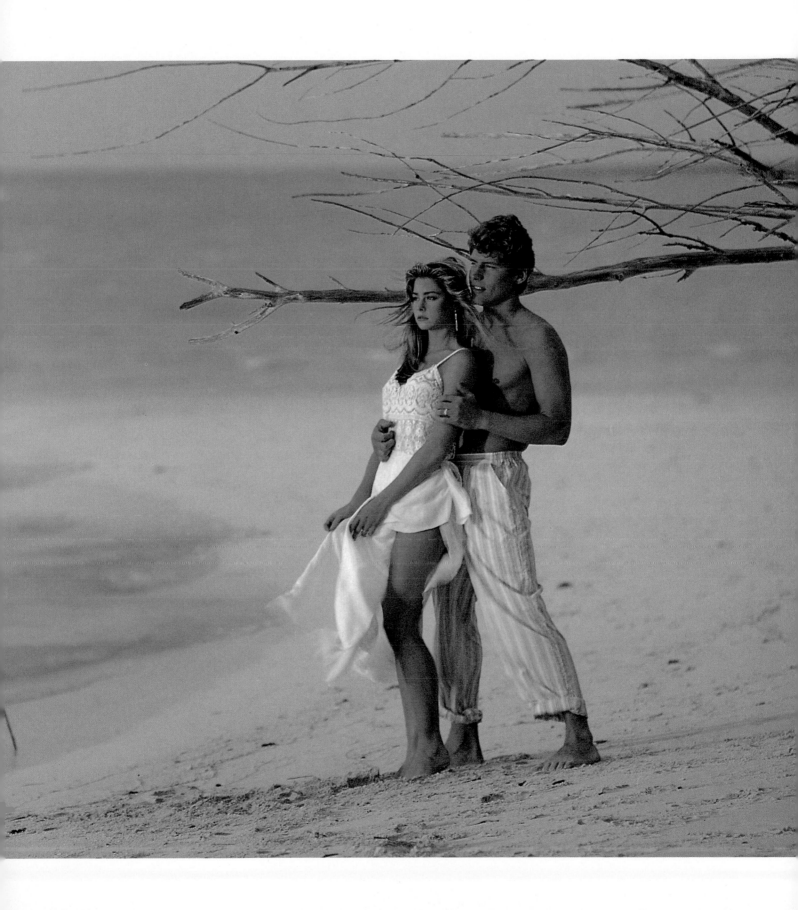

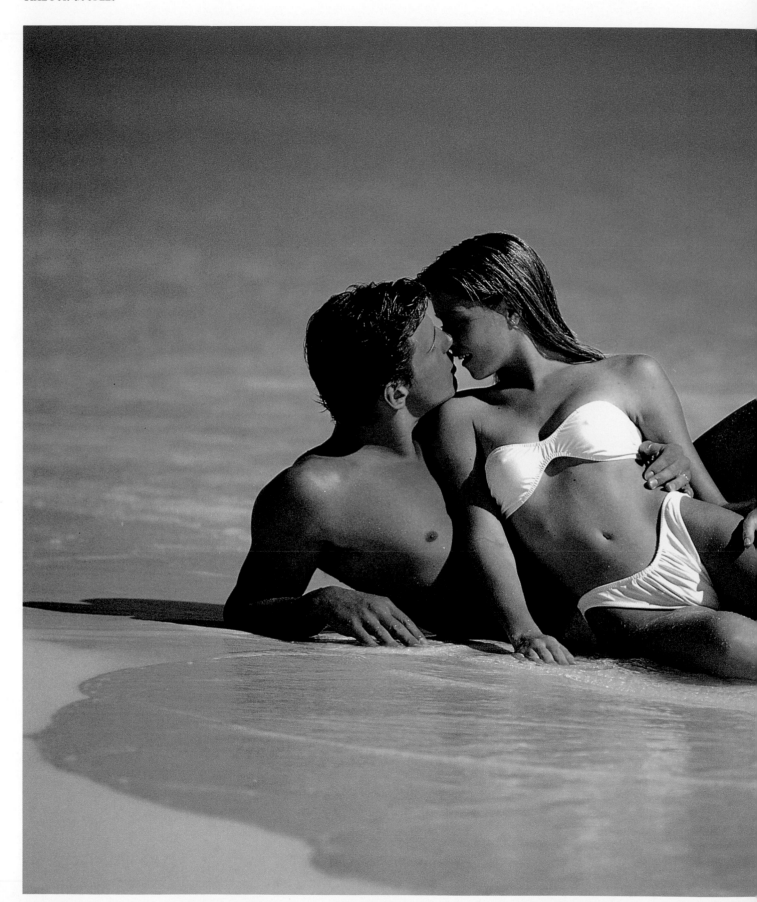

Shot at Treasure Cay in the Bahamas, this photograph shows another wardrobe change. This quiet shot of a couple relaxing at the water's edge was made with a 180mm lens and Kodachrome PKM 25.

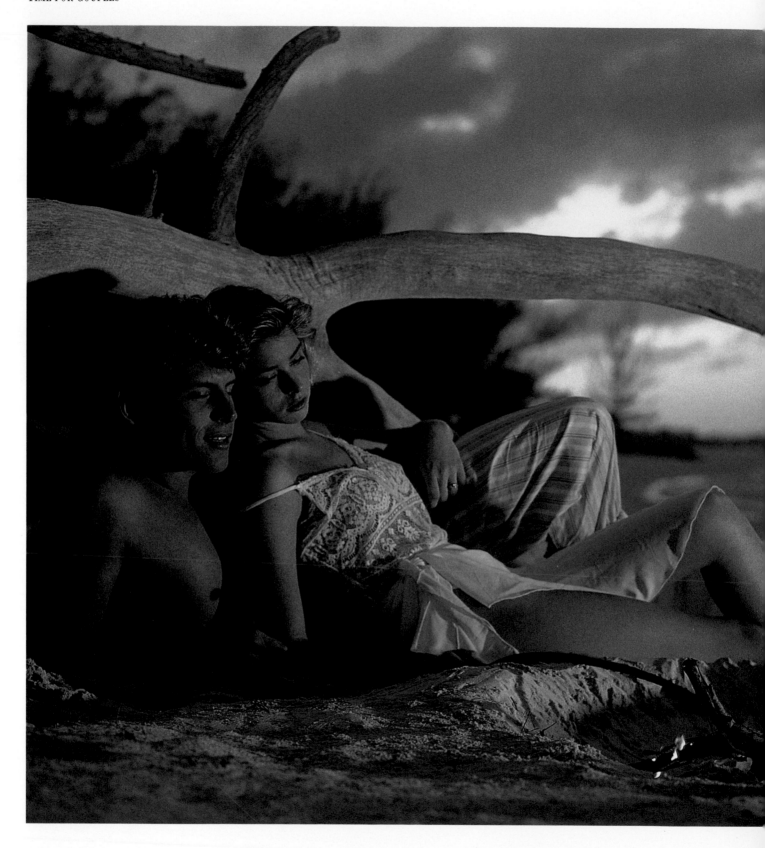

When shooting in the Caribbean, I try to take advantage of every sunset because the weather is so unpredictable. For example on my most recent shooting on St. Lucia, I had just one good "late-afternoon light into sunset" day out of seven. The only good sunset took place on the first evening I was there. Fortunately, I had already scouted the locations and was prepared to shoot. After a full day of shooting on the beach, we left a couple of hours free to set up this series. The log was moved, a portable strobe was partially buried in the sand, the wardrobe was changed, and the models' hair and makeup were fixed. Then we waited for the sun. Just as I started to shoot, the clouds moved in and partially covered the sun but there was enough color in the sky for me to continue.

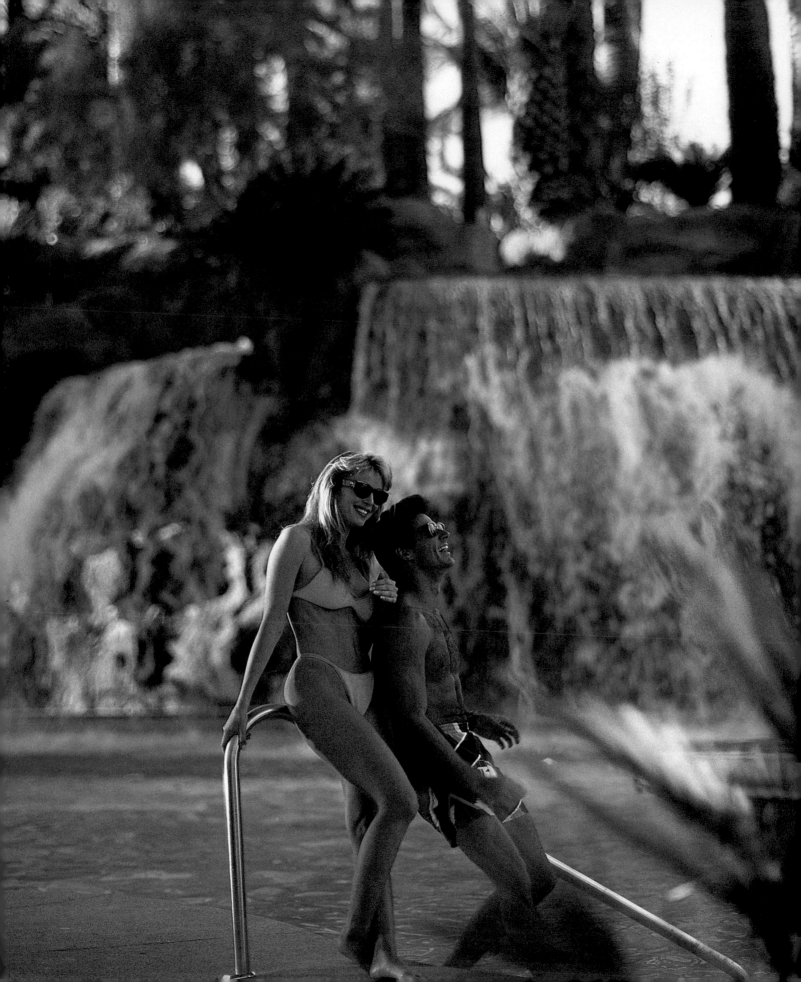

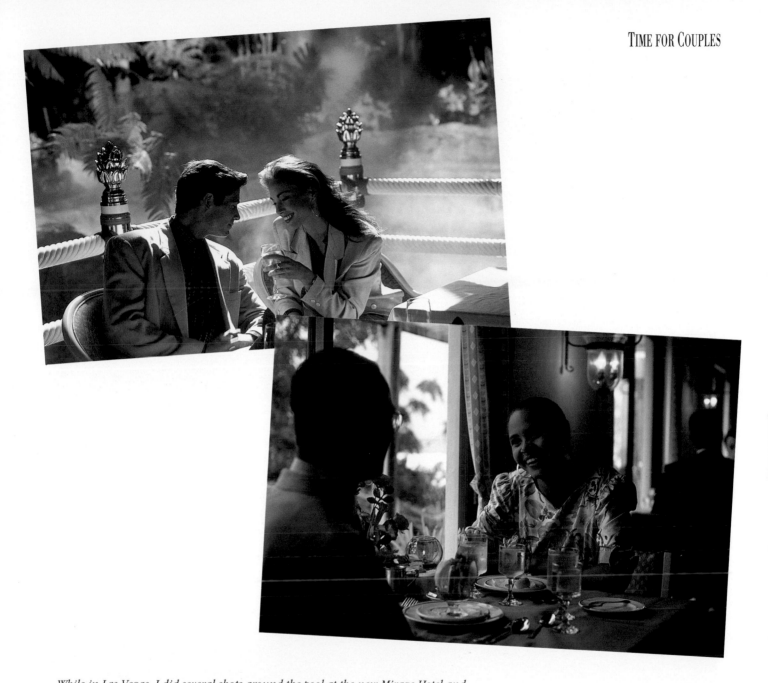

While in Las Vegas, I did several shots around the pool at the new Mirage Hotel and Casino. I used a long lens to photograph a couple at the edge of the pool (opposite page), which made it look as if it has a quarter mile of shoreline. I made another shot of the Mirage's tropical rainforest (top), which is located in an atrium off the lobby and is surrounded by several restaurants. I feel that intimate shots like this one are more successful than grand shots that show a large number of people dining. Here I used the available light in the atrium and a Norman 200B at the camera as fill.

On location on Bermuda, I made this photograph (bottom) by mixing the strong daylight and the restaurant's tungsten lighting. This wasn't what I had originally planned, but we were running about two hours behind. So I had to improvise, promising to be in and out in fifteen minutes.

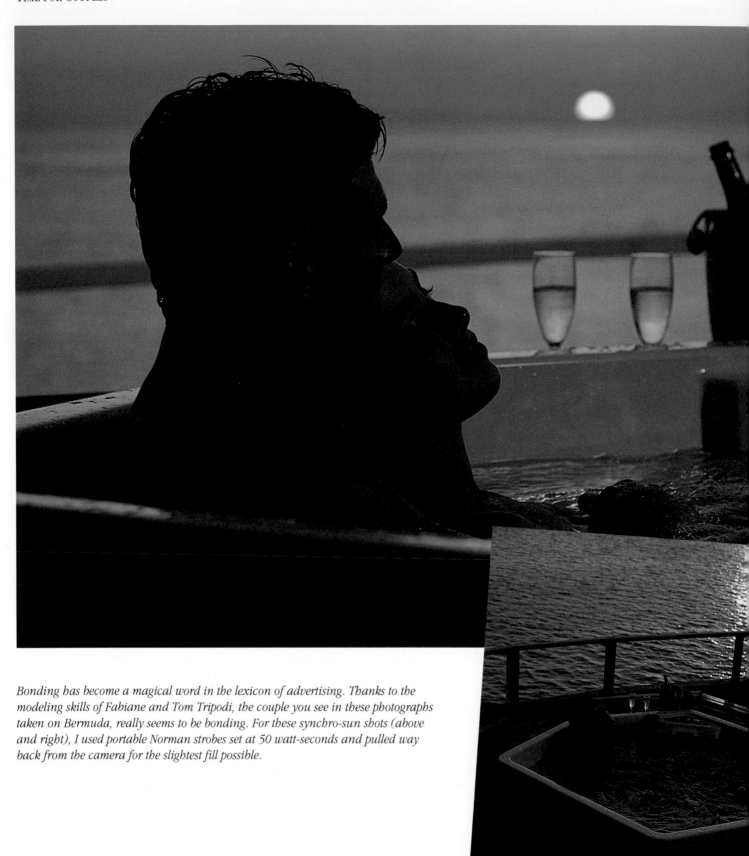

Bonding has become a magical word in the lexicon of advertising. Thanks to the modeling skills of Fabiane and Tom Tripodi, the couple you see in these photographs taken on Bermuda, really seems to be bonding. For these synchro-sun shots (above and right), I used portable Norman strobes set at 50 watt-seconds and pulled way back from the camera for the slightest fill possible.

Photographing a couple having cocktails at sunset, a synchro-sun situation, I illuminated the scene with a Dyna-Lite 1,000 watt-second strobe using only one head set at 250 watt-seconds (top). You should set up this type of shooting at least half an hour ahead of time. You should also be sure that everything is working properly and that you are ready to go. The sun drops very rapidly during the last few minutes before it sets. You can see the subtle color changes that take place so quickly at that point. After the sun had sunk below the horizon, I made a more stylized, less intimate shot (above). I turned off the strobe and exposed for the sky, silhouetting the models. These shots were made on Kodachrome PKM 25.

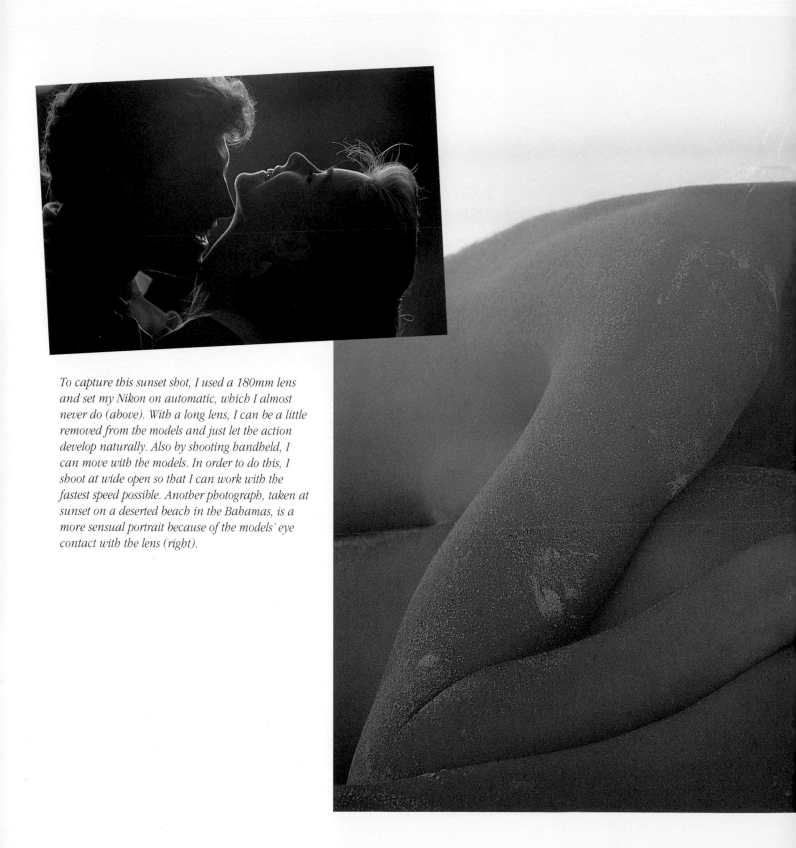

To capture this sunset shot, I used a 180mm lens and set my Nikon on automatic, which I almost never do (above). With a long lens, I can be a little removed from the models and just let the action develop naturally. Also by shooting handheld, I can move with the models. In order to do this, I shoot at wide open so that I can work with the fastest speed possible. Another photograph, taken at sunset on a deserted beach in the Bahamas, is a more sensual portrait because of the models' eye contact with the lens (right).

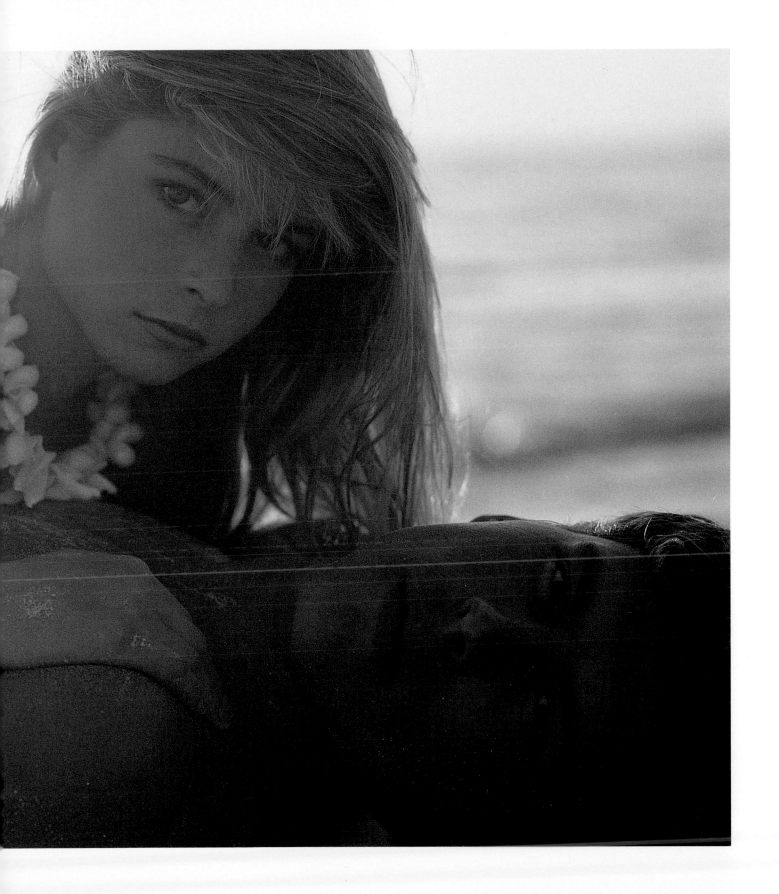

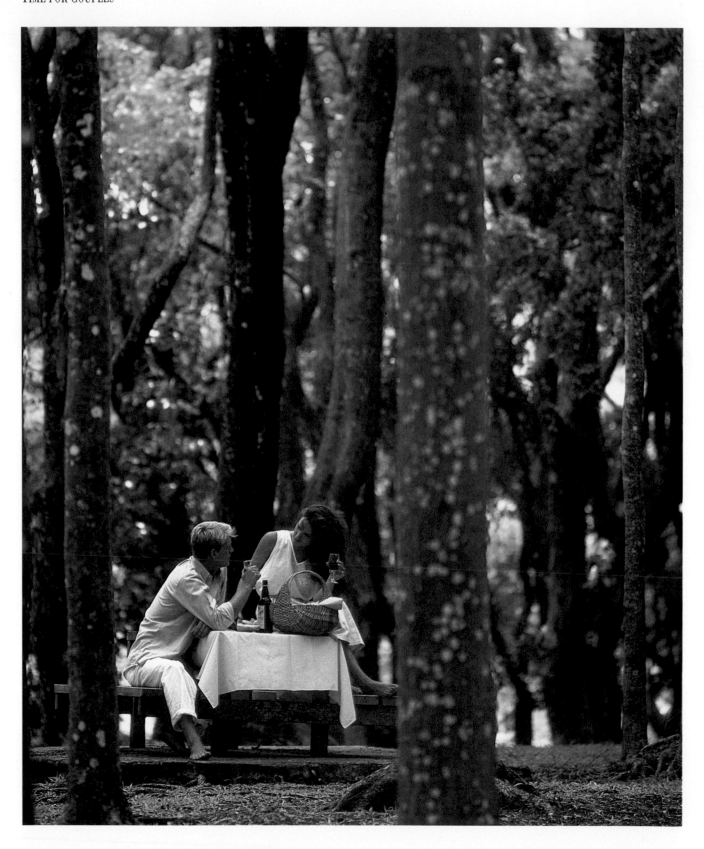

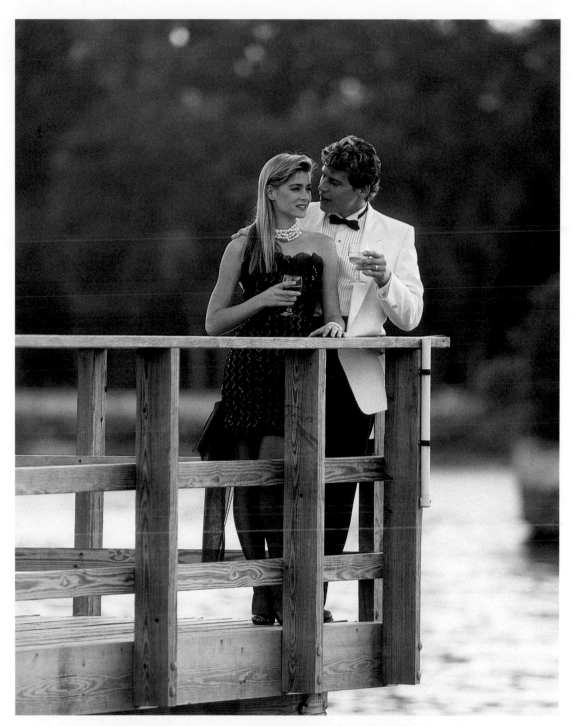

To photograph a picnic in a park in Barbados, I chose Kodachrome, a 135mm lens, and a CC 10R filter because of the many green leaves filtering the top light (opposite page). This red color-correcting filter removes some of the cyan, leaving the skin tones more neutral. The formal fashion shot was made on Paradise Island with a 300mm lens (above). Models Lisa Acomando and Chris Breed worked particularly well together and required very little direction.

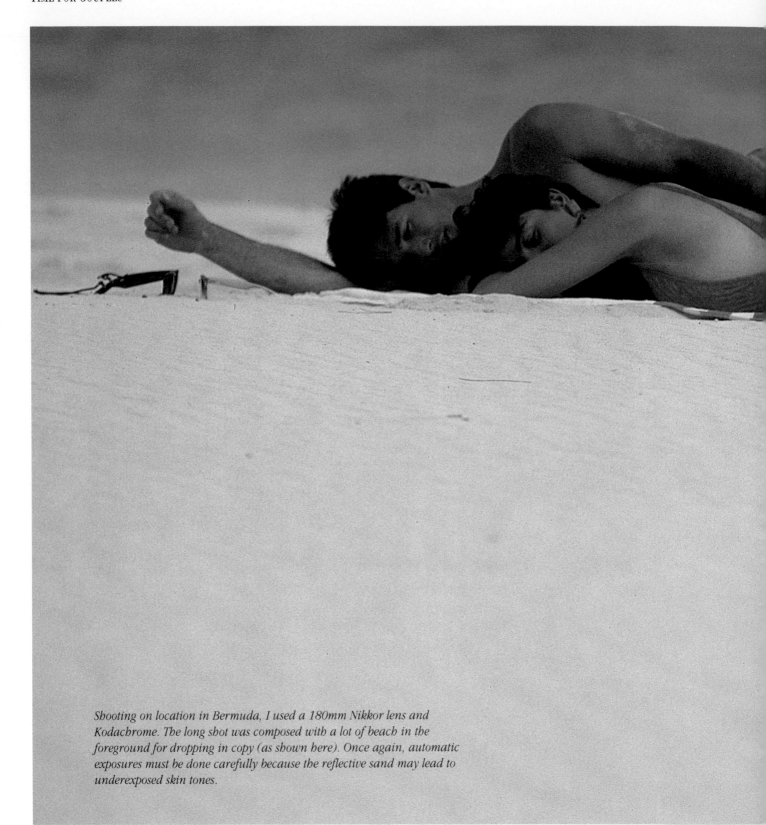

Shooting on location in Bermuda, I used a 180mm Nikkor lens and Kodachrome. The long shot was composed with a lot of beach in the foreground for dropping in copy (as shown here). Once again, automatic exposures must be done carefully because the reflective sand may lead to underexposed skin tones.

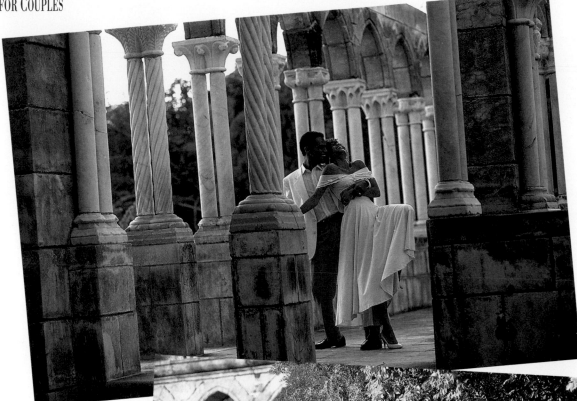

For this series shot in a cloister on Paradise Island in the Bahamas, I worked in reverse. Using Kodachrome PKM, I started with a long lens because that was how I saw the shot when my staff and I were scouting (opposite page). I then switched to a standard lens in order to deliver the maximum number of alternatives to the art director, although I felt that the long-lens shot was superior (above). We then moved around to the front of the cloister. From this viewpoint, I was able to catch the last rays of the sun, which had just popped out in time for sunset and created another entirely different mood (right).

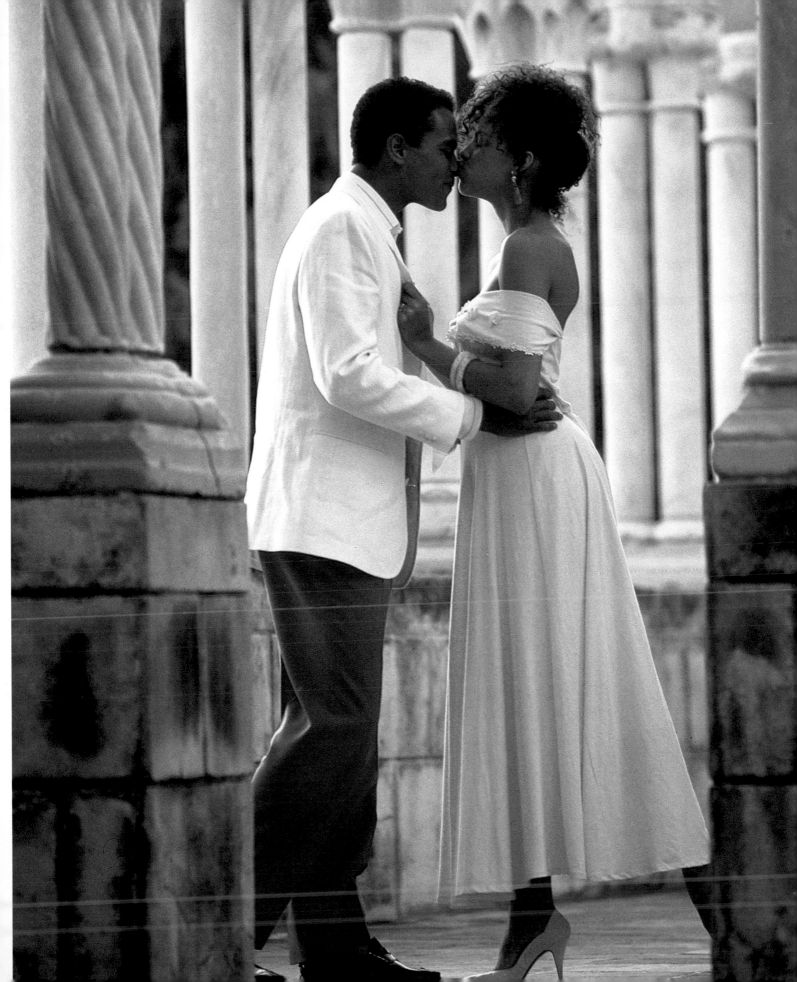

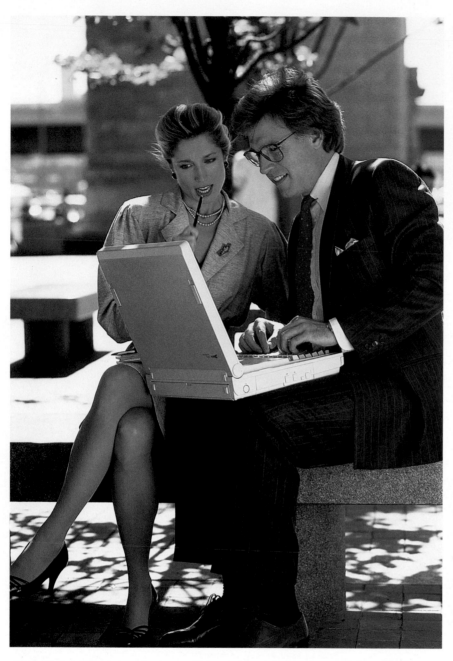

Stock photographers must be aware of any new trends that they can photograph to illustrate what's happening in the marketplace. As soon as laptop computers became a viable product available to consumers, I rented one for a day and with two of my favorite "real-people" models, Susan Van Horn and Tom Fitzsimmons, shot a number of locations in New York's Wall Street area. After photographing them together on a lunch break, I made individual shots of them to capitalize on the situation.

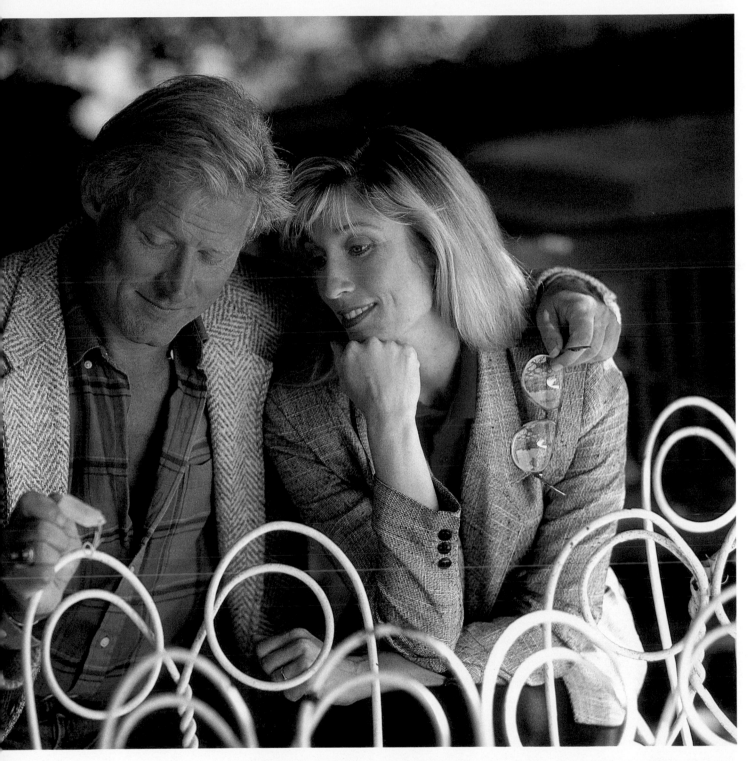

Here, a couple, models Susan Van Horn and Robert Sporre, shops for antiques. When I shoot for stock, I aim for between 10 and 12 situations, and try to get variations within each one during a day's production shoot. This plan includes wardrobe changes for each location change to maximize the effort. Stock shootings must be well planned, so you can move from one location or situation to another and waste little time. The models should look and act as natural as possible. Simple gestures, like putting an arm around the shoulder should look believable, not forced.

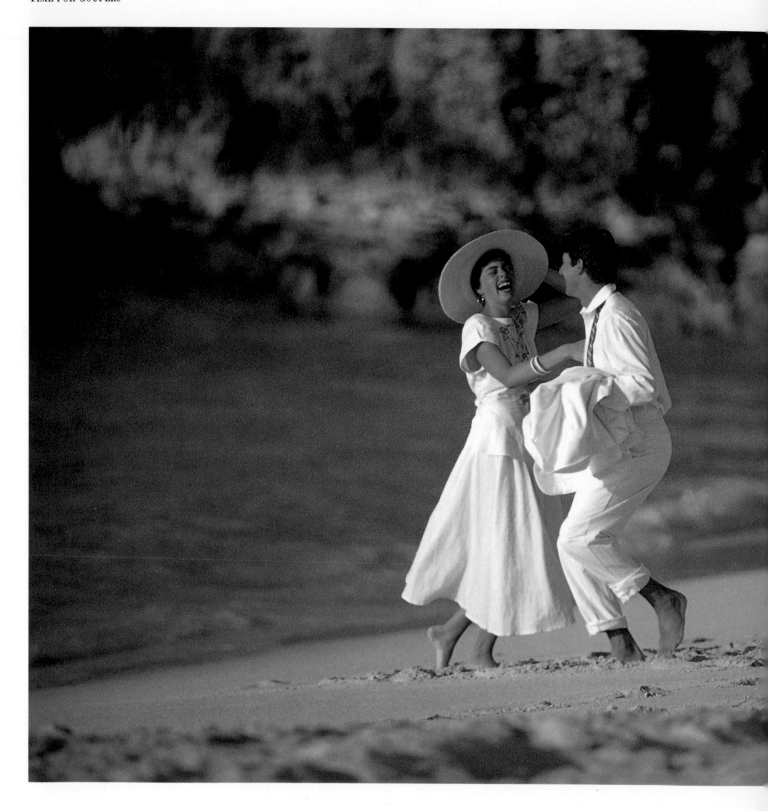

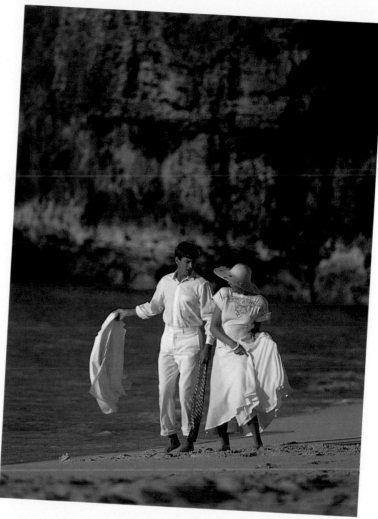

One of the most difficult problems with shooting stock is not repeating yourself. For example, when I photograph a couple walking on the beach, casting becomes very important. I know that with Tom Tripodi and Fabiane, I have talent working with me who contribute to the shoot. For these appealing pictures, I put a 300mm F2.8 lens on my camera and turned them loose on the beach. They just started clowning around. I used Fujichrome 100 for its extra speed and warm colors.

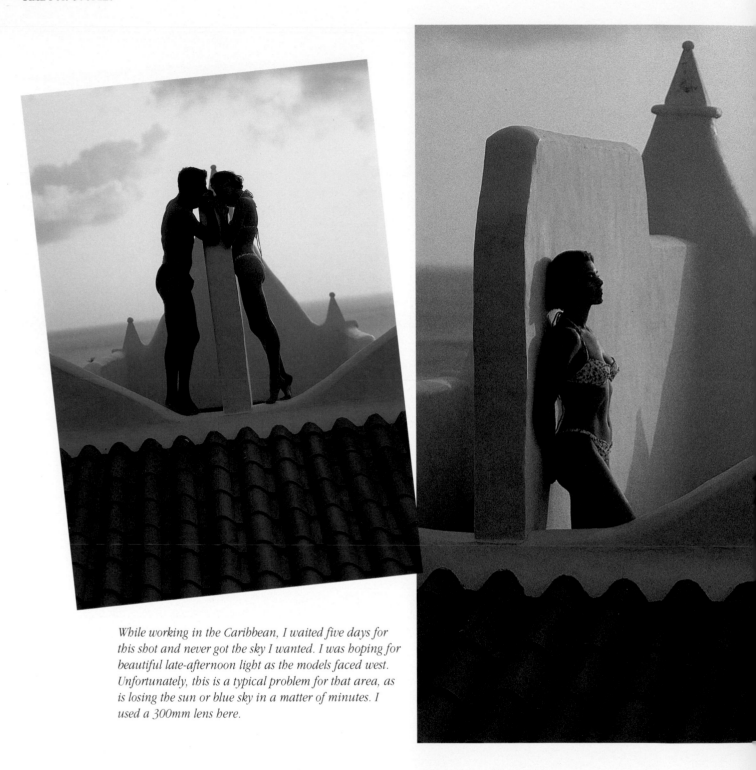

While working in the Caribbean, I waited five days for this shot and never got the sky I wanted. I was hoping for beautiful late-afternoon light as the models faced west. Unfortunately, this is a typical problem for that area, as is losing the sun or blue sky in a matter of minutes. I used a 300mm lens here.

Here, I was working in Barbados at the ruins of an old sugar plantation house. This romantic couple was informally but stylishly dressed for the occasion, not overdone. After making this shot with a 50mm lens, I then moved around the models with a 135mm lens.

After shooting a number of straight shots in my New York studio for stock, my staff and I went uptown to get the shot I really wanted of a sophisticated couple out on the town. But not everything always works according to plans. We got caught in a terrible traffic jam on the way to the location I wanted, the spot where upper Park Avenue starts to drop down toward Grand Central Station. We arrived at the location 30 minutes late, which ruined my plans for shooting Kodachrome. So I switched to Fujichrome 100, pushed it two stops to ISO 400, and worked without the strobes. The resulting shots are dynamic.

INDEX

J. Barry O'Rourke, a photographer whose work regularly appears in such magazines as *Seventeen, Ladies Home Journal, Woman's Day, Brides,* and *Newsweek,* is co-owner of The Stock Market and serves on the board of directors of the Advertising Photographers of America. He is also the author of *How to Photograph Women Beautifully* (Amphoto, 1986).

Editorial concept by Robin Simmen
Edited by Liz Harvey
Designed by Jay Anning
Graphic production by Hector Campbell